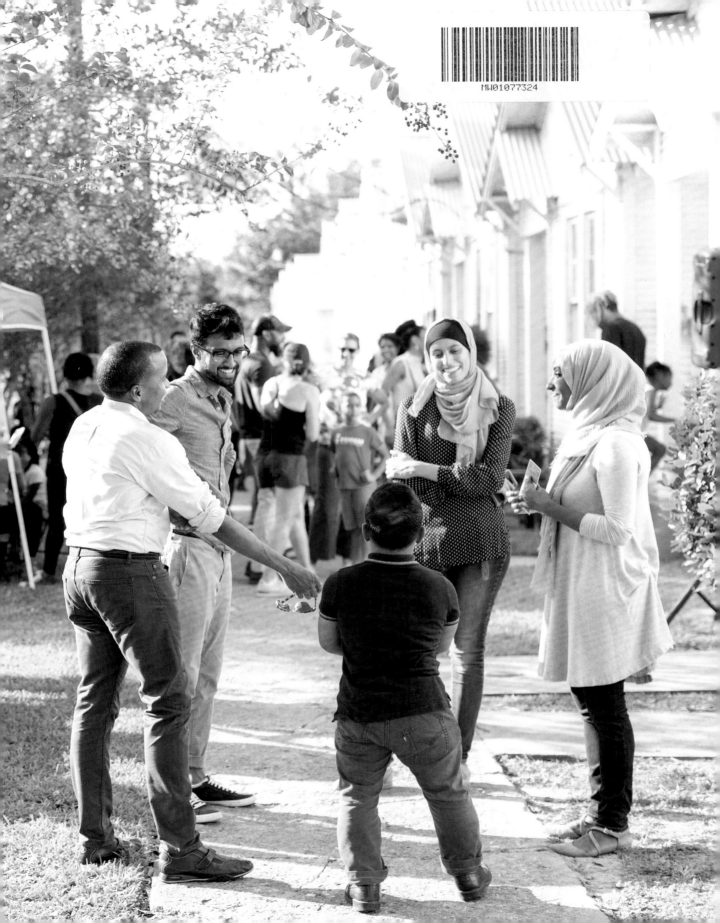

COLLECTIVE CREATIVE ACTIONS

PROJECT ROW HOUSES AT 25

Ryan N. Dennis, Editor

with contributions by

Sandra Jackson-Dumont

George Lipsitz

Assata-Nicole Richards

Danny Samuels and Nonya Grenader

PROJECT
ROW
HOUSES

Collective Creative Actions: Project Row Houses at 25 is published with generous support from Marion Boulton (Kippy) Stroud (1939–2015) and the Elizabeth Firestone Graham Foundation.

**Graham
Foundation**

Programming at Project Row Houses is generously supported by The Brown Foundation; Communities Foundation of Texas; John R. Eckel Jr. Foundation; Fidelity Charitable; First Unitarian Universalist Church; Greater Houston Community Foundation; the City of Houston through Houston Arts Alliance; Houston Endowment Inc.; The Kinder Foundation; Lewis Family Charitable Foundation; John P. McGovern Foundation; The Andrew W. Mellon Foundation; Mid-America Arts Alliance; Picnic; Louisa S. Sarofim; Texas Commission on the Arts; Leroy and Jean Thom, T-L Foundation, Inc.; and The Andy Warhol Foundation for the Visual Arts.

Library of Congress Control Number: 2018951691

ISBN: 978-0-692-12642-4

Text edited by Donna Ghelerter
Designed by Linda Florio, Florio Design

Cover: Aerial view of Project Row Houses during Round 41, curated by Ryan N. Dennis, 2014; pp. 1, 116: Opening and community market during Round 47, curated by Ryan N. Dennis, 2017

Published by Project Row Houses
2521 Holman Street
Houston, TX 77004
projectrowhouses.org

Distributed by

DUKE UNIVERSITY PRESS

Printed in the United States by GHP, CT

CONTENTS

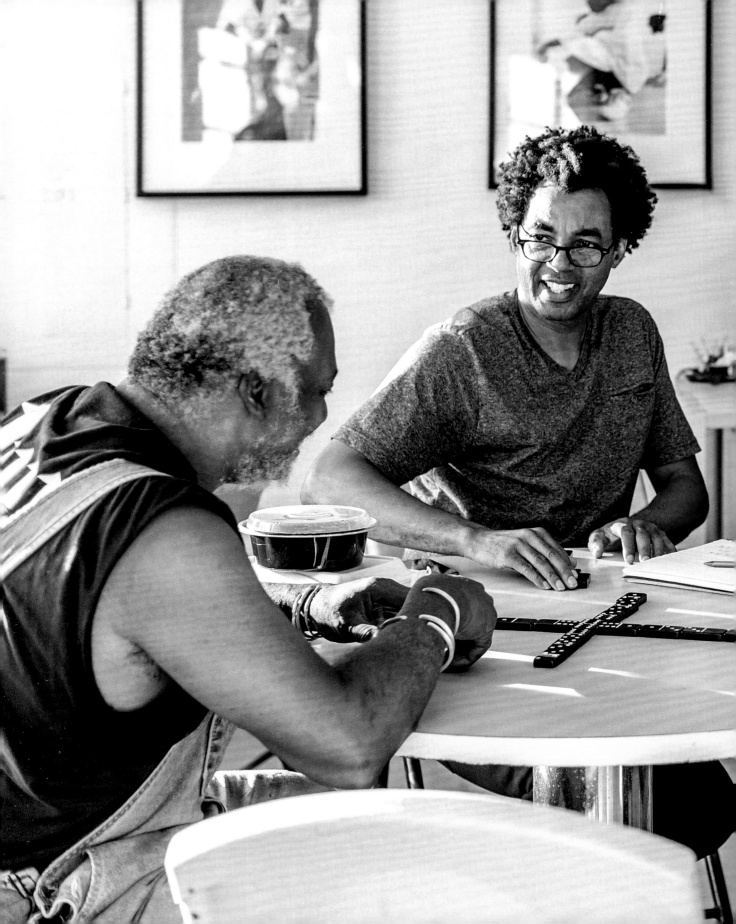

Co–Founder's Foreword

Imagination played a major role in conceiving Project Row Houses. But twenty-five years ago, I would not have imagined that I would be challenged to reflect on the history of Project Row Houses. Now that that time has come, I find myself at a loss to synthesize the many lessons learned, values generated, moments of importance, etc. But maybe that's not the most important thing at this juncture and for this book. It occurs to me that the most important thing at this point is to acknowledge the many critical collaborators who made it possible to celebrate twenty-five years. Below is a chronology, through my eyes, of the pivotal people and institutions that made their mark on this journey.

Arthur Shaw—My philosophy and political strategy teacher. It was my study with this man that gave me an intellectual framework for my work as an artist and activist. **Deloyd Parker and S.H.A.P.E. Community Center**—I learned what it means to be an activist through this man and S.H.A.P.E. Community Center. **James Bettison, Bert Long Jr., Jesse Lott, Floyd Newsum, Bert Samples, and George Smith**—I would not have had the courage to pursue the project without the support and comradery of this group. **Anonymous high school student**—Who challenged me to make work that goes beyond the symbolic and address practical issues. **Dr. John Biggers**—His work gave a context for the project. **Joseph Beuys**—His concept of social sculpture provided the fundamental idea for PRH as an art project. **Michael Peranteau and DiverseWorks**—Presented the vision that PRH could garner support to be a sustainable entity. **Diana Glass**—First administrative support. **Deborah Grotfeldt**—Left DiverseWorks to give PRH the administrative foundation to pursue its mission of bringing artists into the community context. **National Endowment for the Arts**—Courageously responded positively to a very underdeveloped proposal that we leveraged to get additional support. **Cultural Arts Council of Houston**—Followed the NEA and was the second institution to pledge support for the project. **Elizabeth Firestone Graham Foundation**—Provided the first foundation funding. **Bishop Frank Rush, Houston Praise and Worship Center, and Reverend Robert McGee, Trinity United Methodist Church**—First churches to support the project. **Earnestine Courtney**—First neighbor to support the project. **Ernie Attwell**—First community historian to help contextualize the project in the Third Ward. **Houston Endowment**—Provided first land acquisition fund that allowed the acquisition of land for affordable housing. **Lillie Fontenot, Anita Smith, and the Missouri City (TX) Chapter of The LINKS**—First community supporters. **Dean Ruck and Nestor Topchy**—Former studio mates who were the first skilled-carpenter hands-on volunteers. **Charles Drayden**—First attorney and board chair. **Ray Ray, Kendrick, Anthony, Richard, Silas, Sabrina**—First neighborhood youth to embrace the project. **Betty Pecore**—Largest first individual donor and volunteer. **Stennis Lenoir**—First architectural support. **Sheryl Tucker de Vazquez**—Provided architectural support. **Paul Winkler and the Menil Collection**—Led the House Challenge that challenged cultural and community institutions to adopt renovating one house each. **Cory Webster and Amoco Torch Classic**—Provided the first large group of volunteers. **Andrew Speckhard and Chevron volunteers**—First and most sustained corporate supporter. **Sheila and Isaac Heimbinder**—Led the effort to start the Young Mothers Residential Program. **Julie Lazar and Tom Finkelpearl**—First

national curators to acknowledge the contribution of PRH to contemporary art. **Dr. Nelda Lewis**—Developed the Young Mothers Residential Program. **Benjamin Benson**—Neighborhood volunteer who watched over the property throughout the nights. **Hamdiya Ali**—Became the identity of the youth education program. **Assata-Nicole Richards**—Participant in first group of young mothers who personified why the Young Mothers Residential Program was a valuable asset to PRH. **Danny Samuels, Nonya Grenader, and Rice University**—Designed and built the first new-construction house. **Rudy Bruner Award for Urban Excellence**—Gave PRH its first national award. **Cheryl and Percy Creuzot**—First neighborhood business leaders to support the project. **Hubert Finkelstein**—Donated the Eldorado Building and properties. **The Andy Warhol Foundation for the Visual Arts**—Provided funds to retire PRH's property debt. **Bill Hill**—Strong board leader and prominent donor. **City of Houston Department of Housing and Community Development**—Provided significant funding for the first new-construction duplexes. **State Representative Garnet Coleman**—Became the biggest supporter of all housing initiatives. **Cheryl Parker**—As executive director, led PRH through its most challenging legal and financial period. **Edwin Harrison**—Provided critical resources to PRH during its most challenging legal and financial period.

This list is by no means exhaustive. It is merely a reflection of those who stand out in my memory during critical moments of the first ten to twelve years. Since then, many others have shaped this twenty-five-year journey at various stages along the way and put their handprints on the project. And now, I'm excited to step back a bit and support the future generation of contributors as PRH embarks on its next phase of what I hope is many more years.

Rick Lowe
Co-Founder

Director's Foreword

Twenty-five years ago, James Bettison, Bert Long Jr., Jesse Lott, Rick Lowe, Floyd Newsum, Bert Samples, and George Smith sought to create an environment that uplifted art as a tool to mobilize and enrich their community through collective action. Lowe located the five-city-block site that is now known as Project Row Houses (PRH)—an organization steeped in the belief that art can transform communities.

Inspired by the work of Joseph Beuys and his emphatic conviction that "everyone is an artist," these visionaries would go on to make one of the greatest social sculptures the world has ever known. From the moment you step onto Holman Street, you feel art and creativity emanating across the site. The illustrious row houses serve as the canvas, providing a space for artists to showcase their work, a refuge to young mothers and their children, and a bridge for artrepreneurs to realize dreams of offering economic goods and services to their beloved community. Project Row Houses is a gathering place, a safe haven, and a hub of culturally rich activity, unapologetic in its belief that the people it serves and its community matter.

Project Row Houses' enigmatic legacy has been interpreted in many ways by those who choose to engage with its work. PRH has cemented its place at the forefront of social practice, challenging the ways artists express themselves and exhibit their work, while showing the world that art can be a driving force in how a community rebuilds itself after long-term, government-sanctioned disinvestment.

Project Row Houses lifts up the poetry of the everyday, reinforcing the idea that a game of dominoes or a weekly potluck can build the social capital necessary to inspire collaboration, innovation, and change in a place full of hope but with a scarcity of resources. It is this self-determining approach that has defined PRH's work in Houston's historic Third Ward—a commitment that everyone has value, and that artists' direct engagement with a community can result in creative solutions to complex issues. Dr. John Biggers's belief that "self-dignity and racial pride could be consciously approached through art" permeates PRH as we seek to expand conversations about negative stigma and stereotypes, while exalting the rich history and culture of those who choose to call Third Ward home.

While the scale of PRH's work has grown over the past twenty-five years, our core belief remains the same: we empower people and enrich communities through engagement, art, and direct action. Our art programs, enrichment initiatives, and neighborhood development activities reflect that every aspect of our work is art, produced creatively and intentionally through a cultural lens.

As we embark on the next twenty-five years and beyond, PRH will continue to serve as a foundation for partnerships that not only inspire hope, but also serve as an impetus to change the way that art is perceived. It is not possible to capture all that PRH has accomplished thus far, but this book offers a comprehensive look at how PRH has used art, historic preservation, and human empowerment to create an extraordinary social sculpture in one of Houston's oldest African American neighborhoods.

Eureka Gilkey
Executive Director

Acknowledgments

Many individuals, businesses, organizations, institutions, and funders have contributed to the work of Project Row Houses (PRH) during its phenomenal twenty-five-year journey. Although we cannot name each one in this book, we are supremely, eternally grateful for their support. However, there are a few who we must explicitly name, recognizing that without them, PRH would not exist, particularly its visionary founding artists—James Bettison (1957–1997), Bert Long Jr. (1940–2013), Jesse Lott, Rick Lowe, Floyd Newsum, Bert Samples, and George Smith—who in 1993 wanted to positively impact this Third Ward neighborhood and enrich the community through the celebration of art and African American history and culture. Inspired by the work and philosophy of legendary artists Dr. John Biggers and Joseph Beuys, they created PRH—a social sculpture (an artwork that includes human activity and strives to structure and shape society or the environment). The founding artists' work at PRH has influenced and continues to inspire the field of social practice and contemporary art. PRH is honored to have hosted, engaged, learned from, and built with all the artists, mothers, residents, youth, community stakeholders, developers, and individuals who have allowed the organization to become more deeply invested in ways to grow with the Third Ward community. The journey and development with all of these individuals has elevated the conversations we've had and the projects we've created together.

Special thanks to those Houston individuals who have now joined the realm of the ancestors, and who invested in PRH's success with benevolent human and financial resources: Earnestine Courtney, William Hill, and Isaac Heimbinder; and to those from Houston and around the country who continue to lift up the work of PRH: Annette Bracy, Mark Bradford, Cheryl and Percy Creuzot, Sheila Heimbinder, Dr. Nelda Lewis, Julie Mehretu, Adelaide de Menil, Louisa S. Sarofim, Gerald and Anita Smith, and Nina and Michael Zilkha. PRH extends a special recognition to volunteers from Chevron, DiverseWorks, The Menil Collection, and the Museum of Fine Arts, Houston, who were instrumental in our efforts to clean the site and refurbish the houses.

PRH's past and current philanthropic partners include institutions that have been a consistent source of funding throughout its life, those that have recently joined its growing list of supporters, and those that recognized the significance and potential of PRH with multiyear financial resources to realize its vision: The Annenberg Foundation; The Brown Foundation; The Bruner Foundation; Chevron; Communities Foundation of Texas; John R. Eckel Jr. Foundation; Fidelity Charitable; Ford Foundation; Greater Houston Community Foundation; Hohlt Wich Foundation; Houston Arts Alliance; Houston Endowment Inc.; The Kinder Foundation; Kresge Foundation; Lewis Family Charitable Foundation; John P. McGovern Foundation; The Andrew W. Mellon Foundation; Mid-America Arts Alliance; National Endowment for the Arts; The Rauschenberg Foundation; South Texas Charitable Foundation; St. Luke's Episcopal Foundation; Surdna Foundation; Texas Commission on the Arts; Leroy and Jean Thom, T-L Foundation, Inc.; and The Andy Warhol Foundation for the Visual Arts.

PRH's programming has been enhanced by working in partnership and collaboration with the following community organizations and institutions that serve our Third Ward community.

They include but are not limited to: Art League Houston; Aurora Picture Show; Community Artists' Collective; Cynthia Woods Mitchell Center for Arts; Doshi House; Emancipation Economic Development Council; First Unitarian Universalist Church; Houston Baptist University School of Art and Sciences; Local Initiatives Support Corporation; Massachusetts Institute of Technology Community Innovators Lab; The Menil Collection; Merry Quilters; Mary Susan Moore Medical Society; Museum of Fine Arts Glassell School of Art; Picnic; Rice Design Construct (formerly known as Rice Building Workshop); Rice University Department of Art; Row House CDC, Saint Arnold Brewing Company; St. Thomas University School of Art; Sankofa Research Institute; S.H.A.P.E Community Center; Texas Southern University College of Art; Third Ward Community Cloth Cooperative; Trinity United Methodist Church; University of Houston's College of Art, Center for Art and Social Engagement, and School of Social Work; and Village Liquor.

Project Row Houses would not exist without the hundreds of artists and cultural workers who have created, installed, and showcased work; taught classes and workshops; and engaged with our beloved community; as well as former and present PRH board members and staff who have governed and kept the doors open; and also dedicated volunteers who shared the workload. For your contributions, we offer sincere gratitude and appreciation.

Finally, for the publication of *Collective Creative Actions: Project Row Houses at 25*, the first publication in our twenty-five-year history, we offer many thanks to our contributors: Ryan N. Dennis, Sandra Jackson-Dumont, George Lipsitz, Assata-Nicole Richards, Danny Samuels and Nonya Grenader who worked under rapid deadlines to produce their engaging texts; to Michael McFadden for his input on the "25 Actions at PRH and Beyond" section; to Linda Florio of Florio Design, for shaping all of the book's parts into this exciting visual story; to Donna Ghelerter for editing and invaluable assistance through the publication process; and to all those who edited, proofread, sorted through volumes of photographs, and in any other way moved this project to publication. This book has been a work in progress for five years, and without funding from Marion Boulton (Kippy) Stroud (1939–2015), who we regret will not see the final publication, and the Elizabeth Firestone Graham Foundation, whose endless patience and consideration has our highest gratitude, it would still be a dream.

Thank you for your love. Thank you for your support. We look forward with joy and excitement to the next twenty-five!

Art,
Community,
and
Neighborhood
Development

at PRH and beyond

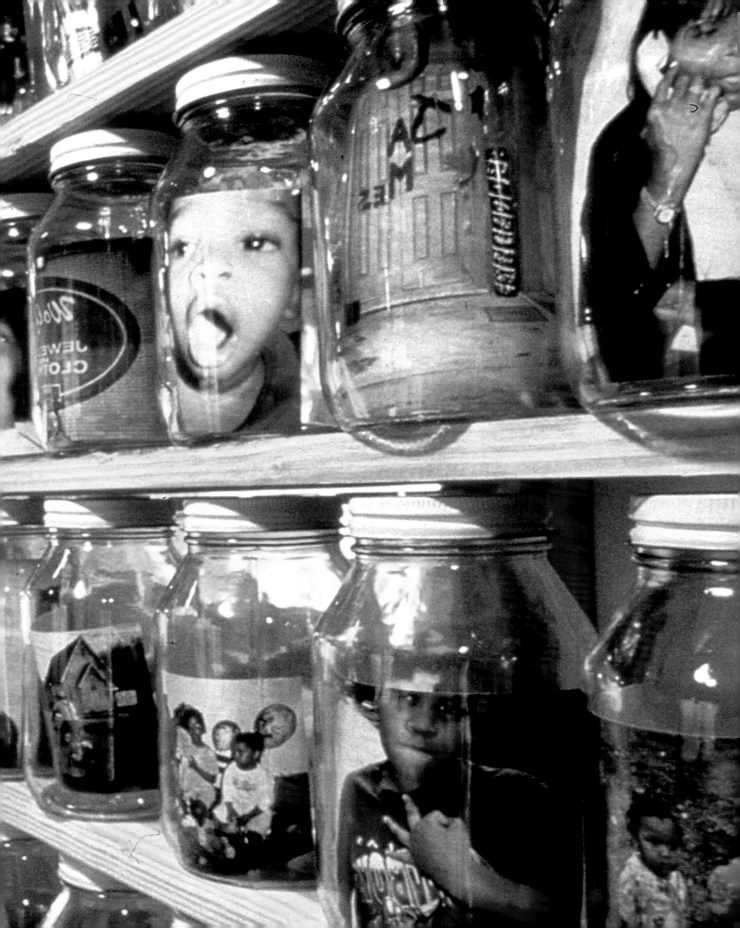

Artists in Action

Ryan N. Dennis

All art becomes public the moment it appears in a place where it can be seen without permission by anyone who happens to be in the location where it is on display.
— bell hooks, "House Art: Merging Public and Private," *Row: trajectories through the shotgun house*

The current political climate is fraught with a whirlwind of sociopolitical issues that have civilians in both the United States and internationally questioning their place in the world. These concerns swirl around police brutality, uprisings on historic figures that result in the takedown of public monuments, and immigration policies that are literally ripping families apart. These are just a few of the many national dilemmas that have left people on different sides of the political spectrum. The climate of this administration is met with distrust, fallacies in leadership, and ultimate shock, which begs the question: How, in 2018, can we be in a state of such repeated histories from our past and witness a decline in political progress? Twenty-five years ago, in Houston, Texas, the city was dealing with its own set of issues: the education system was being questioned, and students were being rezoned from overcrowded schools to underutilized ones; the local arts scene was extremely segregated, which was happening throughout the country; and the housing stock was shifting because of ongoing disinvestment, and the start of gentrification that was being acted out on communities of color. The impact of this shift in the housing market decreased opportunities for fruitful, positive economic development and for the preservation for both people and places.

From then to now, while civil liberties are being taken away, artists, organizers, and activists have always tried to shed light on and speak to these issues in a myriad of ways that allow for imaginative opportunities to engage and transform people, their ways of seeing, and ultimately their ways of being. Artists' installations in the shotgun-style row houses allowed for the mission of Project Row Houses to grow, and for the organization's values and place in the Third Ward community to evolve. In this brief essay, a few select art installations and projects, among the many that have occurred over Project Row Houses' twenty-five years, illustrate the artists' will to utilize creativity and imagination, and to speak to issues that advance our society's development (for a complete list of Artist Rounds and participants see this publication p. 100).

Project Row Houses (PRH) is a community platform that enriches lives through art with an emphasis on cultural identity and its impact on the urban landscape.[1] PRH was created out of conversations, from a place that, in some ways, was responding to a lack of inclusivity from institutions and organizations throughout Houston. Black artists living and working, both collaboratively and

Tracy Hicks, *Third Ward Archive*, 1996. Round 4

independently, were trying to create opportunities for themselves that were not being given. In Third Ward, one of Houston's six historic wards, located on the southeast side of this sprawling city, seven artists were coming together to create space for the changes they desired to see in this predominantly African American neighborhood that was in a severe economically depressed state. Known as the "magnificent seven," artists James Bettison, Bert Long Jr., Jesse Lott, Rick Lowe, Floyd Newsum, Bert Samples, and George Smith all came from different backgrounds and utilized different artistic mediums. Working in their ways throughout the city, they fought to carve out space to have exhibitions in more established institutions.

Throughout their time of developing friendships, meeting, being frustrated, and raising their concerns to others, they found themselves coming back together based on the study and mentorship of Dr. John Biggers. In 1949, Biggers, a painter from North Carolina, created the art department at Texas Southern University, a historically black college in Houston's Third Ward. Until his death in 2001, Biggers had a profound impact on the founding artists, and was an impetus to establish what would become Project Row Houses. Lowe, while volunteering at S.H.A.P.E Community Center (Self-Help for African People through Education), was invited on a tour with city officials, developers, and organizers. When the tour arrived at a block of dilapidated shotgun row houses at Live Oak and Holman Streets, the area was identified as "the worst" block on their citywide route and at risk of being torn down. This became a pivotal moment for Lowe, who went back to the group of artists and communicated not only what was being planned, but also how what he had seen was reminiscent of Biggers's painting practice. In his art, Biggers uplifted the importance of the shotgun-style houses, which hold great significance in black vernacular architecture, by communicating black life and the migration patterns of black people from Africa to the Caribbean and into the U.S.'s southern states. His paintings integrated African motifs and symbolism, prominent black women like Harriet Tubman and Sojourner Truth, and mothers who cared for not only their children, but also for the children in the communities that were built on the backdrop of the shotgun houses. Biggers's influence, coupled with pedagogical ideas inspired by German artist Joseph Beuys who coined the term "social sculpture"—which is understood as how we shape and mold the world around us—was the means to create action for Lowe and his cohort.

Working collaboratively to determine a plan and mount projects at Live Oak and Holman Streets became key. This important junction would have a lasting impression on the Third Ward community and throughout the worlds of art, social service, architecture, and neighborhood development. While I am certain, at the time of these gatherings and determining, collectively, what was about to take place, these artists didn't necessarily know what type of impact this project would have. Resources were tight, and the vision for building a long-term, sustained organization was not the focus. Their drive and determination to respond, in their way, to this neighborhood, which was repeatedly told and shown that it had no value, was of greatest importance to them. PRH has become a unique case study on the power of possibility, the use of narrative shifting, and the

Drive-By exhibition illustrated on the cover of *High Performance* magazine, Spring/Summer 1995

creative impulse to do something different, even when you don't know what is to come.

The first exhibition at PRH, titled *Drive-By*, set the tone for the type of installations that would be presented in the future. During this time, there were many volunteers on the site helping to clear trash and debris. Lott and Lowe invited artists to paint on plywood that was temporarily covering the front windows on the exteriors of the unrenovated row houses. This action and the exhibition's naming were based on two things: one being the fact that a number of people were driving by, curious about what was happening to these spaces that were dilapidated for a long period of time, and the second being a response to the number of drive-bys that were taking place in the neighborhood in the early 1990s. Drive-by shootings are commonly defined as an incident in which the shooter fires a firearm from a motor vehicle at another person, vehicle, building, or other stationary object.[2] Twenty-five years ago, this was a common issue, one with a profound impact on families throughout the country, especially in underserved communities. *Drive-By* included work by Houston-based artists Joe Dixon, Jesse Lott, Rick Lowe, Israel McCloud, Angelbert Metoyer, Bert Samples, and Ron Smith, and subtly prompted people to think about an issue that was having a negative impact on this community and others like it. The exhibition consisted of mostly abstract paintings with some representational imagery. While there was not an explicit call to action from this exhibition, it made a substantial and visible intervention in a long-neglected site, and opened dialogue around safety and security in the Third Ward. The exhibition would also serve as an opportunity to gather with other artists to present work in public space. From this exhibition, and after PRH was officially incorporated in the summer of 1993, the Public Art Program was launched.

The Public Art Program at PRH encourages artists to take risks and experiment in their practice while exploring new ways of working outside of the studio. Through studying the complex history of the neighborhood (though many of the artists know it deeply from their families and life experiences), connecting with Third Ward residents, and understanding the changes that come with working within this context, artists create site-specific installations that live inside the art houses or the public spaces of the neighborhood.[3] Through PRH's version of exhibitions, called Rounds, we have showcased more than three hundred artists in installations inside (and sometimes on) each 538-square-foot shotgun-style art house. We place importance on the installations having multiple points of connection and dialogical exchange with visitors through workshops and other types of programming that are shaped in a collaborative process between PRH and an exhibiting artist. The Rounds are not prescriptive. They are truly sites of possibility that over the years have had tremendous impact.

One of PRH's early art projects, *Third Ward Archive*, an installation conceived by Dallas-based artist Tracy Hicks for Round 4, in 1996, and produced with the Third Ward residents, embodied the founders' ideas on neighborhood engagement. Hicks decided to work "with people who are preserving a community, the Third Ward of Houston, a place of rich history suffering from urban decay."[4] He provided youth and families with cameras to document their daily

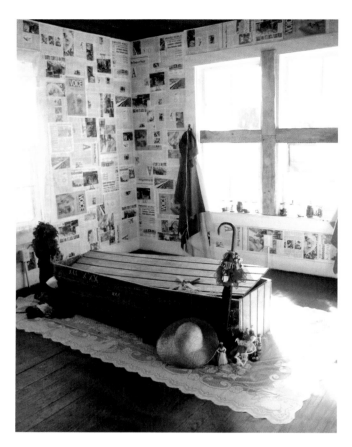

Rashida Bumbray, *Sign of the Judgement: A Shout House for New Orleans*, 2006. Round 25

lives and experiences, with no parameters other than just being. The outcome would be a film-processing station within the installation and over three thousand images that were placed in mason jars, each containing a photograph and a note. The installation made a maze-like route in the art house, with the goal of honoring the residents at that time. *Third Ward Archive* valued the neighborhood and the people that called Third Ward home. While there have been many changes caused by gentrification, this installation reminds us of what was there, of why we fight so hard to keep residents from being displaced, and of the beautiful side of black life in the mid-1990s in Third Ward.

Project Row Houses' art installations often reflect the political and cultural times. In 2005, Hurricane Katrina, and the city's neglected infrastructures, hit New Orleans, Louisiana, displacing nearly 400,000 residents.[5] Houston took in as many as 250,000 evacuees. Black America was stunned by the lack of support being given by governmental agencies, and American rapper and culture influencer Kanye West proclaimed that "George Bush doesn't care about black people" on national television. In response to these trying times, that were still very lively a year later, artist, choreographer, and curator Rashida Bumbray responded to the spirit in Round 25. She created *Sign of the Judgement: A Shout House for New Orleans*, which addressed a need for spiritual healing and acknowledgment for those who were feeling the effects of their treatment post-Katrina. The installation was an active ritual space for the ceremony of the ring shout, an old spiritual dance developed during slavery.[6] *Sign of the*

Judgement connected the cosmologies of the low country and the bayou for displaced New Orleaneans in Houston. The space was activated and performed by Bumbray and members of the Oberlin College Dance Diaspora. While Bumbray wasn't able to stay for the whole viewing period of the Round, the installation was infused with the artist's spiritual presence, aided by sound recordings, blue bottles (which historically have represented capturing evil spirits that would become stuck), and related newspaper clippings that surrounded the internal walls of the space.

Through the Rounds, many local and national artists launched their careers at the very site of Live Oak and Holman. PRH has been an opportunity for artists to enhance their practices by having a supportive environment that allows for freedom, and encourages liberation for artistic practice. Within the field of socially engaged and community-based practices, the Rounds have exemplified how artists and collectives can work in, around, and with community as a means to take action in both subtle and bold ways. There is always a fine line that is being negotiated to explore the balance of poetic gestures coupled with the necessity to respond to this hyperlocal community in a way that is generative, accessible, and educational. The Rounds are a dimension of the Public Art Program that serve as a point of engagement, a point, as Lowe states, "for people outside the community to participate, to benefit from the opportunity to interact in a different kind of environment."[7] To date, the Public Art Program has expanded to include residencies, fellowships, temporary public art commissions, and a slew of other public-facing programmatic activity with the goal of engaging the many individuals and worlds that we want to build new futures with, while maintaining the essence of the organization, which is to celebrate community through art and African American history and culture. The hundreds of installations at PRH over its twenty-five-year history have, like a ring shout, lifted us up, creating a ripple effect that encircles people, places, and communities both local and far beyond.

NOTES

1 See projectrowhouses.org/about/mission-history/.

2 Kelly Dedel, *Drive-By Shootings: Problem-Oriented Guides for Police*, Problem-Specific Guides Series, No. 47, U.S. Department of Justice, Office of Community Oriented Policing Services, March 2007.

3 See projectrowhouses.org for more information about PRH programs.

4 Artist's website, accessed July 10, 2018, http://www.tracyhicks.com/PRHin.htm.

5 Laura Bliss, "10 Years Later, There's So Much We Don't Know About Where Katrina Survivors Ended Up," Citilab, August 25, 2015, https://www.citylab.com/equity/2015/08/10-years-later-theres-still-a-lot-we-dont-know-about-where-katrina-survivors-ended-up/401216/.

6 Leah Falk, "Rebuilding Lives in Art," *The Oberlin Review*, March 2, 2007, http://www2.oberlin.edu/stupub/ocreview/2007/03/02/arts/Rebuilding_Lives_in_Art_.html.

7 Tom Finkelpearl, *What We Made: Conversations on Art and Social Cooperation* (Durham: Duke University Press, 2013), 139.

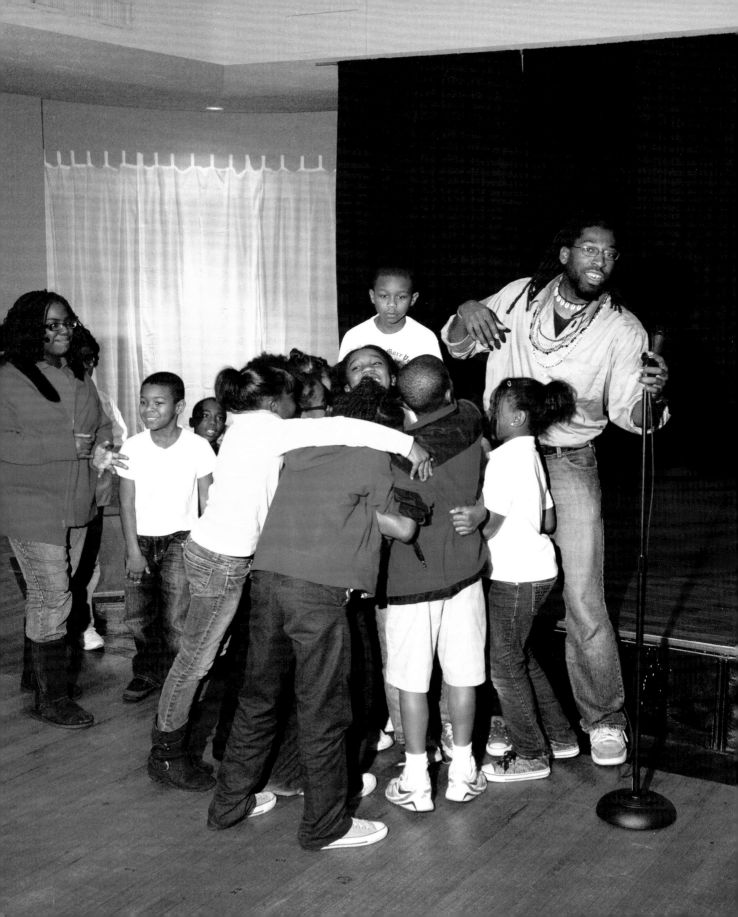

Bound Up: Project Row Houses' Covert Curriculum

Sandra Jackson-Dumont

Let's begin by saying that we are living through a very dangerous time. Everyone in this room is in one way or another aware of that. We are in a revolutionary situation, no matter how unpopular that word has become in this country. The society in which we live is desperately menaced . . . from within. To any citizen of this country who figures himself as responsible—and particularly those of you who deal with the minds and hearts of young people—must be prepared to "go for broke."
—James Baldwin, "A Talk to Teachers," 1963

The 1990s were filled with a range of monumental moments—the United States entered a major recession; news cycle after news cycle was consumed by the Gulf War and ethnic cleansing around the world in places like Rwanda; several iconic movies were released including *Malcolm X* and *Boyz N the Hood*; the Americans with Disabilities Act was signed issuing civil rights protections to individuals with disabilities; Nelson Mandela was released from prison in South Africa; *and* seeds were being planted for the growth of a small and mighty artist project bearing the name Project Row Houses in Houston, Texas.

Artist and founding director Rick Lowe has said that, in 1990, "'a group of high school students came over to my studio,' he recalled. 'I was doing big, billboard-size paintings and cutout sculptures dealing with social issues, and one of the students told me that, sure, the work reflected what was going on in his community, but it wasn't what the community needed. If I was an artist, he said, why didn't I come up with some kind of creative solution to issues instead of just telling people like him what they already knew. That was the defining moment that pushed me out of the studio.'"[1] This early interaction informed the organization's understanding of critical relevance. That young person's challenge to "come up with some kind of creative solution" meant that Project Row Houses (PRH) would need to be, by design, "bound up" with those in proximity.

What does it mean to be in proximity to something, someone, or some place? What are the repercussions or responsibilities associated with the ways in which people are connected viscerally, emotionally, intellectually, and geographically? For most, proximity means to be adjacent to, alongside, or to have just enough distance to understand that you are not of that particular something, someone, or some place. In the case of Houston's PRH, to be in close proximity means be up close, coexisting, collaborating, and catalyzing with folks who live, work, and play near the location, Houston's historic Third Ward. For PRH, following these ideas and values means being all up in it.

Noted activist, academic, and artist Lilla Watson's often-quoted statement says, "If you have come here to help me, you are wasting your time. But if you

Participants of the youth program at Project Row Houses, 2010

Jennie Ash and Carrie Schneider, *Charge*, 2016. Round 44

have come because your liberation is bound up with mine, then let us work together."[2] This notion of being "bound up" is at the center of PRH's creative practice generally, and its education pedagogy more specifically. It is the considerable relationship between proximity and bound-up-ness that is the reason why the organization would not only make work inside the shotgun-style art houses for the community to experience, but moreover it would have to contribute to the community's ecosystem therefore operating as a vested member—making it, at once, in the community *and* of the community. This vibrant new operating system would only see success if it was of significant consequence to all involved. In other words, being "bound up" or closely involved with, radically shifts the gaze from an overseer (artist) of subject (community) vantage point to a proximity discourse shaped by realities, resources, and relationships.

While the PRH approach was informed by many points of view, not the least of which was that of community members, Rick Lowe and the team were inspired by the thinking of conceptual artist Joseph Beuys who developed a theory of "social sculpture" that is "based on the concept that everything is art, that every aspect of life could be approached creatively, and, as a result, everyone has the potential to be an artist."[3] Adopting Beuys's philosophy implied a specific commitment to flagrantly breaking the rules of the art world by subscribing to a new line of thinking—the neighborhood was the studio, the studio operated as a school, a school is made up of the community, the community was the people, and the people was where what mattered resided.

That line of thinking permeated everything with a kind of interwoven shine. Professional artists alongside mothers, children, and elders alike felt the magnetic pull of PRH. That pull melded life's important everyday needs, like childcare, homework help, and social activities, with traditional art-world practices such as artist talks and studio art-making sessions. This fusion was deliberate in an effort to yield intended consequences. It became a hub where folks from various walks of life could get what they needed to be whole, it simultaneously explored and expanded the job description for cultural institutions and artists in society.

In 1995, Project Row Houses founded its education programs anchored in the importance of arts education as a vehicle for self-empowerment, critical thinking, and social responsibility. So often arts organizations launch arts education programs in an attempt to "serve" or "help" those they refer to as "underprivileged" or "at risk." The aid is often delivered from the stance of charity or benevolence. Watson's words critique that attitude and suggest that when working with anyone, including our most vulnerable citizenry, one should work from a place of being bound up. For that very reason, PRH is a beacon of educational and social resources. Social learning is fundamental to their practice. The entire enterprise is a covert curriculum designed to follow the contemporary agenda of the users, but at the core, it fosters interdependence, shares communal accountability, enacts social justice, and explores desire.

With a commitment to quality learning rooted in formal education and intergenerational knowledge sharing, PRH engages contemporary artists to work with young people in the neighboring community through a range of experiences

including mentoring, tutoring, providing positive support, and college planning. From free weekly tutorial sessions for anyone of any age advancing their studies to a robust after-school program, this vital organization presents a full menu of visual and performing arts-based program opportunities for children and youth (K–12), exposing them to the arts while positively influencing their academic progress, honing their analytical skills, and fostering creativity and curiosity through art making.

In 2006, *New York Times* journalist Michael Kimmelman interviewed a beneficiary of Project Row Houses about its impact. The woman, Assata-Nicole Richards, who was one of the earliest participants in the Young Mothers Residential Program (see Richards's essay in this volume p. 24), said, "Well, I had heard Rick was an artist when I got there, but I thought, what kind of art does he do? Then I realized we were his art. We came into these houses, and they did something to us. This became a place of transformation. That's what art does. It transforms you. And Rick also treated us like artists. He would ask, 'What's your vision for yourself?' You understood that you were supposed to be making something new, and that something was yourself."[4]

Today, PRH education work remains imperative to the ecosystem in which it sits. It has also become a strategic model worldwide for unlikely partners to rally for building healthy community with embedded social responsibilities, a sense of place, clear stewardship, and, above all, radical self-care. Following James Baldwin's pronouncement to teachers in 1963, PRH education work is a prototype for what it means to be bound up for life with the "minds and hearts" of one another.[5]

NOTES

1 Michael Kimmelman, "In Houston, Art Is Where the Home Is," *The New York Times*, Dec. 17, 2006, https://www.nytimes.com/2006/12/17/arts/design/17kimm.html.

2 Lilla Watson, in a speech during the 1985 United Nations Decade for Women conference in Nairobi. The quote's original source is unconfirmed, but multiple scholarly texts cite this conference as its origin. However, Watson stated that she prefers the citation to be, "Aboriginal activists group, Queensland, 1970s," because she does not want to take credit for collective-based work. See Mz.Many Names, "Attributing Words," *Unnecessary Evils*, November 3, 2008, http://unnecessar-yevils.blogspot.com.au/2008/11/attributing-words.html; Richard P. Appelbaum and William I. Robinson, *Critical Globalization Studies* (New York: Routledge, 2005), 401; and Christine Morley, Phillip Ablett, and Selma Macfarlane, *Engaging with Social Work: a Critical Introduction* (West Nyack: Cambridge University Press, 2014), 7.

3 "Social Sculpture," Tate, accessed May 17, 2018, http://www.tate.org.uk/art/art-terms/s/social-sculpture.

4 Kimmelman, "In Houston, Art Is Where the Home Is."

5 James Baldwin, "A Talk to Teachers," delivered October 16, 1963, as "The Negro Child—His Self-Image"; originally published in *Saturday Review*, December 21, 1963, rpt. in James Baldwin, *The Price of the Ticket: Collected Nonfiction, 1948–1985* (New York: St. Martin's, 1985), 325.

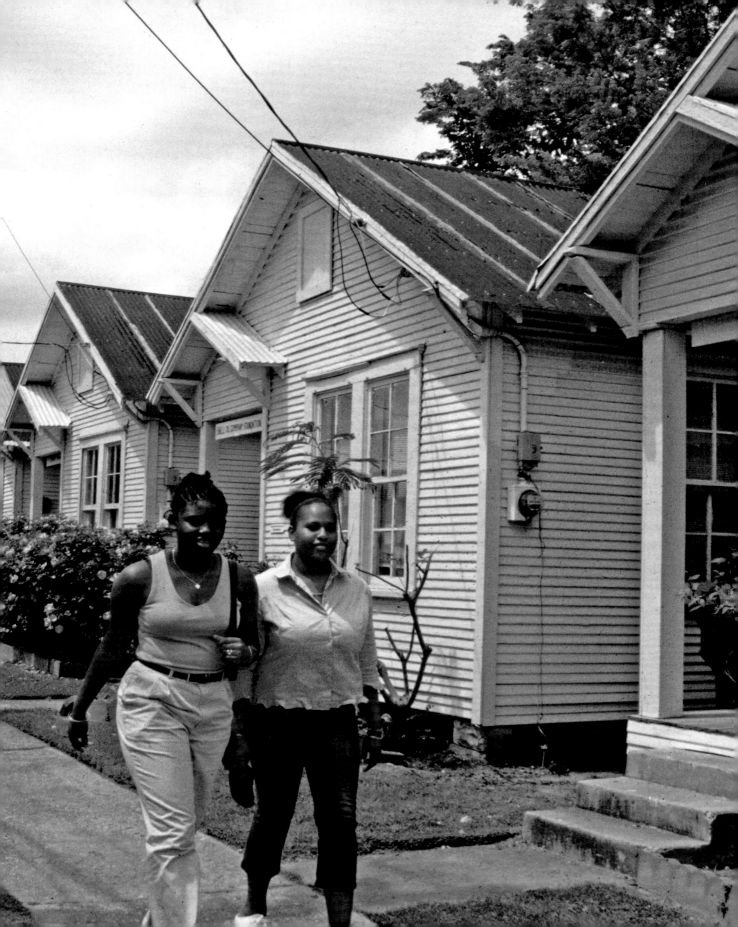

A Soft Place to Stand: Escaping the Interlocking Systems of Race, Class, and Gender

Assata-Nicole Richards

When I reflect on the impact of the Young Mothers Residential Program (YMRP), I am reminded of a poignant saying from West Kerry, Ireland, "You are the place where I stand on the day when my feet are sore."[1] And when I entered the YMRP, in 1996, my feet and entire soul were indeed sore from the enduring legacy of poverty that had narrowed the pathways to opportunities for a better life that I yearned for, for both my son and myself, which is undoubtedly true for the more than seventy women who have gone through the program since its inception at Project Row Houses (PRH) in 1995. While I am certain that this is true for many young women, I would like to note that becoming a mother at the age of eighteen was never my plan and certainly not my ambition. In fact, I belong to a family that considers marriage as foundational. My great-grandparents were married. My grandparents were married. My parents were married. All four of my aunts married, and my only uncle to become a father married the mother of his child. Therefore, marriage has always been, and continues to be, a rite of passage to motherhood for me. However, my sociological training has taught me that there is a tremendously powerful intersection between our personal biographies and the historical dynamics of our larger society. Sociologist C. Wright Mills cautioned, "Neither the life of an individual nor the history of a society can be understood without understanding both."[2]

When I think about why I chose to become a mother at the age of eighteen, I am flooded with memories of my grandparents caring for me throughout my childhood. I am also reminded of my grandmother often telling me that her father did not know his "people" and was left at the mailbox of the couple who raised him. This fact about her father's life created a great sensitivity in my grandmother, who took time to care for all who crossed her path if for any reason they did not have a family of their own. Therefore, when my son's birth mother asked me to assist her in taking care of her son, I did so with great determination and conviction. My decision to take on this responsibility is rooted in a collective history of people of African descent, which has involved a complex and extensive kinship network that includes "fictive kin" as central to the formation of families.[3] Fictive kin are relationships defined by emotional rather than biological ties. These kin of choice have been essential survival strategies employed to combat the catastrophic effects of enslavement that

Young Mothers Residential Program associates walk past the residential houses located on Holman Street, ca. 1997

made it legally, financially, and even psychologically impossible for people of African descent to create stable relationships based on blood relations.[4] The black feminist scholar Patricia Hill Collins accurately observed, "Black women's feelings of responsibility for nurturing the children in their own extended family networks have stimulated a more generalized ethic of care where black women feel accountable to all the black community's children."[5] I did not know it then, but my decision to become a mother on the eve of adulthood was informed by this tradition that continues to endure in the African American community.

Despite the evident challenges of becoming a single, young mother, my choice to assume responsibility for the care of the child who would become my son was fully understood and encouraged in my family and community. Although the situation was by no means ideal, I, and others, believed that my enormous potential, demonstrated intelligence, and incredible fortitude would be sufficient for me to graduate from college as planned and become successful in all my endeavors. Despite the benefits of belonging to a remarkably strong and nurturing family, my grandparents remained permanent members of the working class. Their lifetimes of backbreaking labor never resulted in the accumulation of wealth that they could offer their children and grandchildren to seed our futures. Both my maternal and paternal grandparents escaped the cotton fields of East Texas and Louisiana to migrate to Houston. My grandmothers became maids in the homes of prosperous families, and my grandfathers were general laborers for the city's emerging class of economic and political leaders. Unlike their grandparents, my father and mother were able to graduate high school. Nevertheless, neither of my parents attended college, which placed me at a distinct disadvantage as a single, young mother.

Considering the lack of formally educated individuals in my immediate family, it is somewhat astonishing that I hold a doctorate in sociology. Even more remarkable is that I earned that degree from Pennsylvania State University as a single mother and a graduate from a high school in one of the poorest neighborhoods in Houston. I often compare this rare upward mobility to the seemingly impossible feat of crossing an eight-lane freeway in any major city. For the outside observer, my ability to avoid the well-known negative outcomes associated with becoming a single mother at an early age happened as a consequence of my incredible internal strength and fortitude.

While I readily acknowledge the immense hard work and personal sacrifices that contributed to my educational achievements, I am keenly aware that sheer willpower and determination were not enough to change the trajectory of my life and allow me to escape the interlocking web of race, class, and gender that severely penalizes being black, poor, and female. The YMRP at PRH offers an insightful road map to delineate the critical components that make it possible for single mothers to overcome the psychological and economic barriers that poverty erects. Admittedly, this essay is a highly personal reflection of my experiences in the YMRP. Moreover, it is my intent to provide an analysis of how the program was intentionally created as an intricately woven safety net that has supported the tenuous social mobility of women and children who

Young Mothers Residential Program participant Nikala Asante at the unveiling of houses remodeled by IKEA, 2011

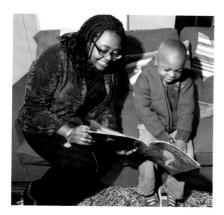
Reading together at a Young Mothers
Residential Program house, 2005

have historically been placed at the lowest socioeconomic strata in communities across the country. To do so, I illuminate the critical roles that three women of significantly different backgrounds—Deborah Grotfeldt, Dr. Nelda Lewis, and Sheila Heimbinder—played in the development of PRH's untried and deliberately holistic initiative.

Positioning itself as an art organization boldly and defiantly responding, with much considered intent, to the needs of its community, in 1995, PRH converted seven shotgun houses into a residential program for young mothers. This action was pivotal in the development of the organization. In the middle of the 1990s, there were many competing issues of concerns in a neighborhood socially and economically ravished by a drug epidemic and its associated violence. However, the organization decided that single mothers would be its priority. PRH's former director Deborah (Deb) Grotfeldt was largely responsible for this decision. Grotfeldt employed her keen ability to secure the necessary resources for the YMRP (as she had done to support artist and PRH co-founder Rick Lowe in establishing PRH's Public Art Program). An interior designer was enlisted to customize and furnish each of the dwellings housing the mothers and their children. Because of her personal experiences of being raised by a single mother, Grotfeldt was deeply passionate about establishing the YMRP as a signature initiative that fulfilled PRH's emerging commitment to integrate an aesthetic approach to the organization's core programming. Her biographical narrative afforded Grotfeldt a deep understanding of the need for mothers and their children to feel protected and supported as a buffer against the enormous economic insecurity that scarred the psyche. And, although Grotfeldt was not a trained artist, her efforts to create the YMRP were critical to PRH being established as a groundbreaking art organization that artist and writer Suzi Gablik called forth in her 1991 seminal book, *The Reenchantment of Art*, which is considered foundational in the emergence of socially engaged art practice.[6] Gablik wrote:

> We are in transitional times, an undefined period between attachment from the old and attachment to the new. It is a good moment to attend to the delineation of goals, as more and more people now imagine that our present system can be replaced by something better: closeness, instead of distancing; the cultivation of ecocentric values; whole-systems thinking; a developed discipline of caring; an individualism that is not purely individual but is grounded in social relationships and also promotes community and the welfare of the whole; an expanded vision of art as a social practice and not just a disembodied eye.[7]

Along the uncharted path of this newly created public art organization, Grotfeldt had two collaborators and visionaries, sociologists Dr. Nelda Lewis and Sheila Heimbinder. Dr. Lewis was a lifelong resident of the historic Third Ward, who grew up on Holman Street across from the shotgun houses that had been designated for the young mothers' program. She was a product of the neighborhood and represented the emerging cohort of African American

professionals who benefited from the gains of the civil rights movement. Dr. Lewis was trained among the social work practitioners, researchers, academicians, and scholars who were expressly committed to social change, justice, and the human development of African diasporic people.

Dr. Lewis, a social work professor at Texas Southern University and lead architect of the YMRP, was superbly prepared to develop a neighborhood-based program that included the critical services and cultural components required for effectively supporting single mothers and vulnerable children. She understood that a comprehensive and holistic approach, based in the strength of the Third Ward community, was needed to anchor our belief in our ability to individually and collectively face the myriad of challenges confronting us as women and mothers. Her understanding was rooted in the transformative work of the National Association of Black Social Workers, which was committed to bridging the divide between research and practice to impact individuals, communities, and systems.[8] At the time of the founding of the YMRP in the 1990s, the vast majority of black political leaders was silent, and continue to be silent, about the devastating effects of President Bill Clinton's 1994 crime bill and 1996 welfare reform act. These policies stigmatized poor African American women, fractured black families, and worsened material conditions of the impoverished. Dr. Lewis's paramount role in this pioneering program served to counterbalance the strong belief that most middle-class African Americans had abandoned, and were alienated from, young urban people of color. Her presence communicated that what was happening to me, and others like me, mattered. She offered empathy and a set of tools to teach us how to move through our long-held fears, immense hurts, and debilitating insecurities.

A second and unlikely collaborator, sociologist Sheila Heimbinder, brought a dynamic perspective to developing and launching the YMRP. Heimbinder, a mother of four, was raised in a large Catholic family living in a close-knit Irish community in Cleveland, Ohio. Heimbinder was patient and resourceful, prerequisites for building relationships with battle-scarred women of color, which necessitated confronting issues of race and class. Her presence in the program challenged our understanding of ourselves and of others. Heimbinder's seeming material reality was dramatically different from ours, which complicated things. However, she taught us a resourcefulness that was familiar and a necessary tool for us to shift beyond surviving our circumstances to thriving in our new environment. Moreover, she left a lasting impression on us because of her steadfast commitment to the program, which included a standing offer for each mother to establish a mutual relationship with her. The significance of this offer was that Heimbinder insisted on us developing a relationship with her at our discretion and on terms that we were allowed to determine. As a consequence, we experienced a shift in power in structural relationships that was subtle but hugely important.

As the survivor of emotional, physical, and sexual abuse, I entered the program fiercely protective of myself, hesitant to form relationships with people who occupied certain structural positions, whose misconceptions and personal biases had served to harm me throughout my life. Today, Heimbinder and I have

Young Mothers Residential Program participants Yvette Chapman and Peregrine Chapman at the unveiling of houses remodeled by IKEA, 2011

a remarkably close bond with one another. With the recent early deaths of both of my parents, she and her husband, Isaac, became my godparents. In their role as my fictive kin, they have provided me with essential support in key areas of my personal and professional life, which has offered me another place to stand when my feet are sore.

In the spring of 1996, I entered the YMRP at one of the most crucial times in my life. Six months previously, I had left my full-time administration position at the Houston Area Urban League to join the AmeriCorps program, which paid me a monthly stipend of seven hundred dollars to provide for my son and myself. The goal was to complete the year of service and earn a five-thousand-dollar scholarship. Considering how long it had taken me to secure employment that offered some dignity and job security, I was plagued with self-doubt and extreme anxiety over my decision to attempt to return to college. However, I was convinced that finishing college would allow me to provide my son with the childhood that he deserved, that I felt that I had been denied. Although my grandparents did not have the opportunity to complete high school, they instilled in me an appreciation and value for education. They read the local newspapers and watched the world news. They were immensely curious about the world, and always encouraged me academically. Yet, pursuing college

was not easy because my family was unable to provide me with any financial support.

During my AmeriCorps service, my son and I lived with a relative and her four children in a two-bedroom, upstairs apartment that cost me $350, taking 50 percent of my monthly earnings. The stress and demoralization of never having enough money among our poor living conditions plunged me into depression. In my interview for admission into the YMRP, I remember crying with Heimbinder and Dr. Lewis as I expressed my growing feeling of helplessness. I had graduated with honors from high school and had been so determined to have a better life. However, I could not seem to achieve this "better" and was beginning to doubt my ability to overcome the many obstacles in my path. My first unsuccessful attempt at college had proven that being smart was not enough. Now, I am forever grateful that in my interview, Dr. Lewis and Heimbinder saw something in me and fought for my acceptance. Rick Lowe urged them against doing so, thinking that I would be disruptive to the program. Though I had not met him personally, he had observed me in my role as a community activist, and he would later describe me as full of undirected anger. Ironically, Lowe and I formed a tremendous bond almost immediately upon my acceptance into the program, and he has been one of my greatest supporters for more than twenty years. However, it was two women, both mothers, who extended me an offer to be a part of a bold project, based in art and entrenched in the belief in human transformation.

I spent approximately eighteen months in the YMRP. During this time, I finished the AmeriCorps program and returned to the University of Houston as a freshman on the scholarship that I earned. I graduated with honors in the summer of 1998 with a full fellowship from the department of sociology at Pennsylvania State University, where I earned my PhD in 2004, and accepted a tenure-track position at the University of Pittsburgh. The impact of the YMRP on my life is profoundly apparent. When I entered college after high school, I had done so as an act of defiance against the despair that had gripped those around me, in my family, and in my community. However, when I returned to the University of Houston, I did so as an affirmation of my value and potential, a belief the YMRP seeded within me. I was no longer running away from my past hurts and failures but toward a life full of possibilities and opportunities.

What distinguishes the YMRP from other traditional social service organizations that serve mothers is that it is rooted in socially engaged art practice, which PRH pioneered. On a fundamental level, PRH created an art-based community for mothers and their children. I have come to realize that artists are excellent role models for demonstrating the power available to us in challenging the limits of our material conditions, and the aptitude for achieving new possibilities with limited resources. As the architects and interpreters of our community, the artists cultivated an environment for us where social realities were constantly being reimagined. Our proximity to individuals who approach art as a process often led to amplification of the intrinsic value of the Third Ward neighborhood and its residents. For me, this was extremely powerful and was evidenced best through the PRH artist rounds held two times

a year, when artists transform the simple row houses into sacred spaces where art happens, rather than merely a place to view artwork. These once discarded houses, which descendants of freed people of African descent built to make a community for themselves and their children, were nurtured and sustained through the celebration of African American art and culture.

From these artists, I rediscovered the value of the materials inside of myself, and learned to better use the resources that YMRP provided me, to create a life that was once unimaginable. Yet, I contend that the full impact of the program must be measured beyond the outcome of my life and my son's life. A more accurate analysis must take into account the ways that the lessons I learned from PRH shape my work as a public sociologist and my leadership as the founding director of the Sankofa Research Institute. As a researcher, I embed myself in communities to engage those most affected by social problems, and provide them with the tools necessary to create the knowledge explicitly needed for affecting change. I now teach others what I learned from artists and through my own transformation, which is the profound truth that we all possess the capacity to sculpt ourselves and the world around us to better serve us individually and collectively. Through me and many others, the legacy of the YMRP endures.

NOTES

1 Pádraig Ó Tuama, "Belonging Creates and Undoes Us Both," *On Being*, March 2, 2017, https://onbe-ing.org/programs/padraig-o-tuama-belonging-creates-and-undoes-us-both-mar2017/.

2 C. Wright Mills, *The Sociological Imagination* (Oxford: Oxford University Press, 1959), 3–10.

3 Herbert George Guttman, *The Black Family in Slavery and Freedom: 1750–1925* (New York: Random House, 1976), 226–28.

4 Andrew Billingsley, *Climbing Jacob's Ladder: The Enduring Legacy of African-American Families* (New York: Simon and Schuster, 1992).

5 Patricia Hill Collins, "The Meaning of Motherhood in Black Culture and Black Mother/Daughter Relationships," in *Toward a New Psychology of Gender*, eds. Mary M. Gergen and Sara N. Davis (New York: Routledge, 1997), 325–40.

6 Suzi Gablik, *The Reenchantment of Art* (New York: Thames and Hudson, 1991).

7 Gablik, 181.

8 See National Association of Black Social Workers, Third Annual Conference, 1998, for the organization's 1968 position statement, https://cdn.ymaws.com/nabsw.site-ym.com/resource/collection/E1582D77-E4CD-4104-996A-D42D08F9CA7D/NABSW_30_Years_of_Unity_-_Our_Roots_Position_Statement_1968.pdf.

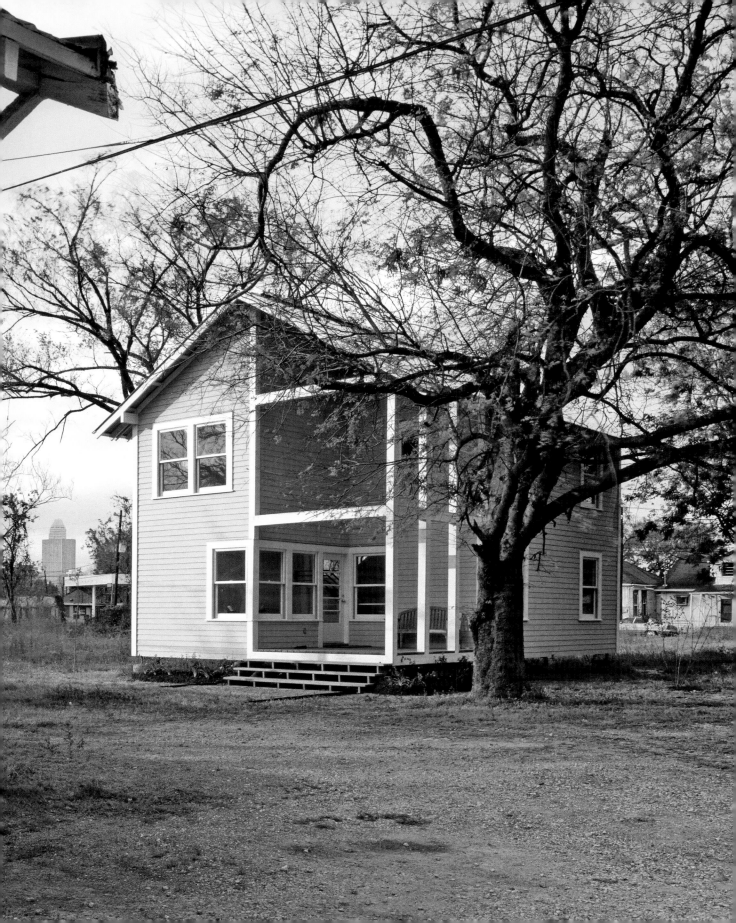

The Collaboration of Rice Building Workshop and Project Row Houses

Danny Samuels and Nonya Grenader

Rice Building Workshop

The Rice Building Workshop (RBW) was established, in 1996, to bring students of architecture out of the studio and into the larger community where their creativity could be challenged by the demands of real-life projects. Twenty-two years and almost seven hundred students later, RBW has designed and built dozens of projects, each one challenging the students in novel ways. The educational benefits are evident: Working at various scales and in diverse situations, RBW students engage all facets of the architectural process, from conception through construction, allowing the act of making to inform every aspect of design. Students work together to test their concepts against the practical realities of technique, budget, and schedule, eventually transforming designs into built contributions to communities beyond their classrooms.

Architecture students (and others too) at all levels, from second year through graduate, participate in RBW, where projects range in scale from furniture to neighborhoods, and involve different stages in the process of design and making. Some projects reach fruition in one semester; others may require several years to move from idea to completion. In the design stages, the seminar works much like an architect's office: Students first meet with clients to develop programs. Then, working in small teams, they generate ideas, consult with engineers, and refine proposals in response to budget, technical details, and code requirements. During construction, students adapt designs to changing circumstances, fine-tune documentation, fabricate components, and generally commit considerable time and effort to the hands-on process of building.

Every building is evidence of the collaborative process—a shared vision among diverse constituent parties. Unlike the typical emphasis in architecture school on the strongly held individual idea, RBW emphasizes the possibilities of collaboration. The student architects work with each other, as well as with clients, consultants, contractors, suppliers, and craftspeople to develop their visions. All RBW projects are for nonprofit clients, and not all are about housing. But of all the valuable learning opportunities offered by the RBW, it is our engagement with community clients, and particularly with Project Row Houses, that has been the most rewarding.

Six-Square House, 1997–99

The Collaboration with Project Row Houses

The relationship between Rice Building Workshop and Project Row Houses (PRH) began in 1997, when Rick Lowe invited us to design and construct a low-cost house prototype on the PRH campus—their first new construction—and has continued for more than twenty years through numerous design, planning, and building projects. The main focus of our work together has been a long investigation into strategies for making houses more affordable and more sustainable, while keeping in mind the larger good to the community.

Project Row Houses and its surrounding community form a coherent and instructive example of vernacular architecture and urbanism. The shotgun house, a type that migrated from Africa to the Caribbean, then to the south coastal United States, is a gem of programmatic compaction and architectural exuberance. This small, simple house, enhanced by the front porch and the backyard, repeated down the street, generated an urban and social fabric that was much greater then the sum of its parts. As reconceived and celebrated by Houston artist Dr. John Biggers, and through the transformative efforts of the artists at PRH, the modest row houses can now be seen as the generator of a rich environment, accommodating the family as part of the larger community.

The community of PRH—staff, artists, and residents—has been an ideal client for young architecture students. In many design critiques, members have exhibited a real sympathy for the students' intentions, while still arguing for the constraints of maintaining a strong connection to the neighborhood. This has encouraged the students to work within a given design framework and still find the means (and the appropriate scale) to express their own ideas. This approach is more akin to participating in a continuing vernacular tradition than to espousing the modernist ethos that is so prevalent in the academy.

The continuing nature of this collaboration means that students not only learn from individual projects, but are able to participate in a longer arc of development than is usual in the school experience. This is an adaptive regime, where lessons are learned, absorbed, and applied to subsequent projects so that the evolutionary development of design is able to occur over an extended period. Here, we have been able to pursue a long line of exploration, research, and development that would not otherwise be available to us.

This work has led not only to multiple housing prototypes and built homes, but also to an ongoing relationship with the Third Ward community. Our work continues now with the Emancipation Economic Development Council (EEDC), a collaborative of community organizations, nonprofits, community development corporations, businesses, local government entities, and other stakeholders. This is a unique coalescence of community effort, and holds real promise to transform the Third Ward community in new ways.

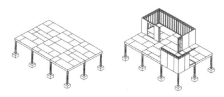 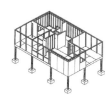 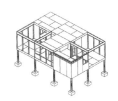 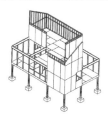 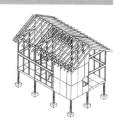

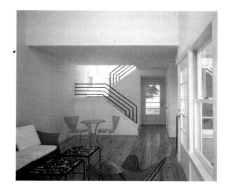

Six-Square House
2419 Division Street, 1997–99

Our initial thought of addressing the question of the affordable house was to make it smaller. The Six-Square House, our first design-and-build project, a 900-square-foot house, was conceived as a low-cost prototype that may be configured in a variety of ways. This modular, panelized house, six-over-six -square units, reflects materials and concepts found in neighboring homes, such as deep overhangs and double-hung windows that are aligned for cross ventilation. Shaded porches extend living space and allow traditional community relationships to develop. Since completion, the Six-Square House has been the home of a mother and her two children. As a prototype, it generated a range of variations.

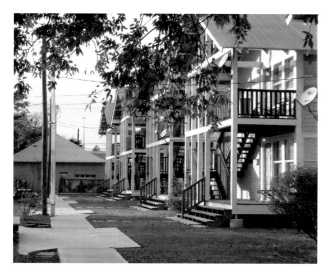

Duplex Apartments
2411–2417 Division Street, 2004
2404–2408 Francis Street, 2008
3451–3457 Anita Street, 2010
3449–3455 Napoleon Street, 3430-3442 Drew Street, 2013

After the completion of the Six-Square House, Project Row Houses, recognizing the pressing need for rental housing in the Third Ward neighborhood, asked the Rice Building Workshop to investigate design possibilities on a site in the

PRH campus. The design emerged as a further development of the Six-Square House. The basic type is a duplex apartment in the Houston tradition, with two units, one above the other, each apartment with two bedrooms and its own front porch, accessed by an exterior stair, all under a generous roof. The students prepared construction drawings for their design in 1998, but the drawings went into the drawer, awaiting financing for the project.

And there they stayed until 2003. The initial construction of 4 duplexes (8 apartments), built by a neighborhood contractor, was so successful that PRH then acquired land behind the first project to construct 8 new structures (16 apartments), this time including three-bedroom types as well. The Hannah Project, on Francis Street, was completed in 2008, with HUD funding through City of Houston Home Funds and participation by many institutional supporters.

After that, Midtown Redevelopment Authority, with the charge to create affordable housing as part of their Tax Increment Reinvestment Zone No. 2 (TIRZ) activities, joined with the Row House Community Development Corporation to develop the duplex design on two sites in the eastern Third Ward, near the University of Houston central campus and the Metro Southeast line. The Anita Street Duplexes (4 duplexes, 8 apartments) were completed in 2010, followed by the Napoleon Street Duplexes (11 duplexes, 22 apartments) in 2013. These are the third and fourth iterations of the original design, this time with an increased commitment to sustainability, durable construction, and universal accessibility.

In all, 54 apartment units have been added to the neighborhood, providing dignified living at very affordable rents, all generated from original student designs.

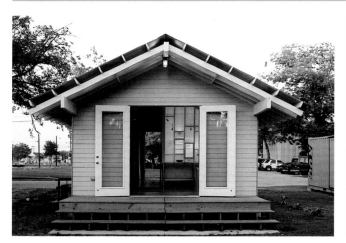
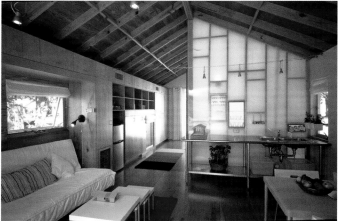

XS House
2304 Stuart Street, 2002–3
Advancing the idea that an affordable house needs to be smaller still, the challenge was to design and build a dwelling of modest size (500 square feet) with a small projected budget ($25,000) while implementing innovative design and construction techniques.

The XS House is a modern interpretation of the shotgun-style row house that once populated many areas in the southern United States. An adjustable footing/foundation system lifts the building off the ground, much like the concrete block footings that are used to support the original row houses located within this community. Cement-fiber plank walls and metal windows are used in place of wood products to minimize maintenance and upkeep. The core of the house is wrapped in translucent polycarbonate, which distributes light throughout the structure. The core contains the bathroom, and accommodates the kitchen along its outer edge. The placement of this single element divides the interior into "large" and "small" spaces that may be furnished in a variety of ways. Sustainable practices were incorporated where appropriate.

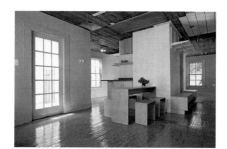

Old Row House, New Core
2503 Holman Street, 2007–8

We realized that the small shotgun house as found at Project Row Houses was itself a model of sustainability. In the renovation of one of the original row houses, we determined that the use of this older housing stock was viable, except that its essential services (kitchen, bathroom, mechanical items) were extremely outdated. For this situation, we designed a new core, and built it in place, delivering modern conveniences to an existing 496-square-foot shotgun house. The square core is a piece of furniture, with each millwork face responding to different domestic uses: living, sleeping, cooking, and dressing. The renovation was seen not only as a single solution for this particular house, but as a general strategy for updating the many typical shotgun-style houses in the neighborhood.

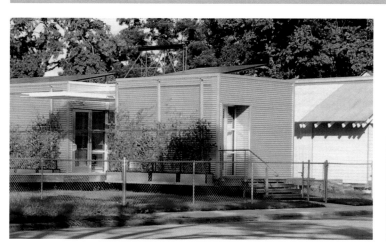

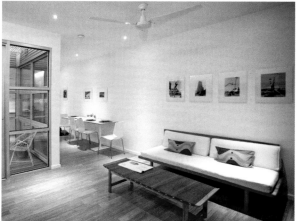

ZeRow House
2306 Stuart Street, 2010

This idea of a compact, yet well-outfitted core became a focus when we were accepted into the 2009 Department of Energy's Solar Decathlon. The house would have to be transported to Washington, D.C., and placed on the National

Mall for the two-week competition with nineteen other universities. The goal with ZeRow House was to pair solar technologies and sustainable strategies with a conscientious attention to affordability.

The house is organized around two cores: a wet core and a light core. The wet core contains all engineered systems associated with solar water and energy in a compact 8-by-10-foot area. The light core serves as the primary source for day lighting, as well as an outdoor extension of interior living space. The shotgun-style view, with an alignment of doors through the house, visually connects public, private, and outdoor spaces.

With 520 square feet of conditioned space and a 700-square-foot overall footprint, the house comfortably provides efficient space for two people. The wood frame is built on a steel chassis, and is designed to be lifted by crane and move down the highway. Solar panels and a solar hot water system provide the energy needed to run the HVAC, appliances, and lighting, as well as hot water for the bathroom, kitchen, and laundry.

After traveling three thousand miles on the highway to Washington, D.C. and back, and being lifted by crane four times, the ZeRow House returned to the Third Ward, where it has been a home for visiting artists at PRH. The house's price tag was less than half the cost of the next most affordable house on the National Mall, and, in a yearlong evaluation, we determined that it met our goal of net-zero energy use.

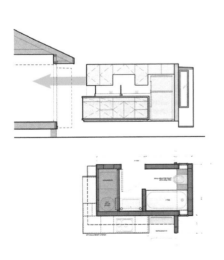

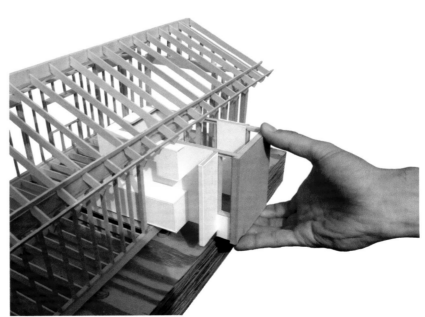

The Core Concept—ModPod
3303 Bastrop Street, 2010–13
Finally, after devoting years of design and construction research and development for low-cost houses, our findings led to the surprising conclusion

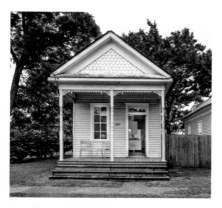

Row House with ModPod

that innovation might now be directed not so much toward the structural and enclosure systems, which have otherwise evolved to a high degree in the marketplace, but to the numerous support systems—electrical, plumbing, HVAC—and fixtures and cabinetworks, which entail the greatest investments of labor and time on any jobsite. ModPod is a prefabricated residential core that consolidates major trade-dependent systems and finishes into a single deliverable unit that may be used in new construction or retrofitted into an existing structure.

In our initial demonstration of concept, the ModPod was designed for insertion into an existing shotgun house. It consists of, and provides the old shell with, a new small bathroom, a kitchen, cabinets along two outside wall surfaces, and spaces for an air handler, water heater, and electrical panel. The ModPod intentionally uses conventional technical systems that will be familiar to builders, though solar PV and water-heater systems can be accommodated. The 8-feet-6-inches-by-12-feet unit was built off-site (at our WorkYard facility, which is also on the PRH campus), as a unit complete with all equipment, fixtures, finishes, and cabinets, including pots and pans. It was then transported and inserted into an opening precut into the side of the existing row house, in a process that took about three hours. The electrical, mechanical, and plumbing systems were coupled to on-site services and branched out to the rest of the residence.

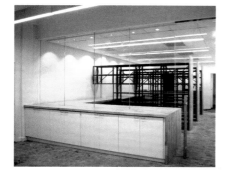

PRH Archive
2314 Elgin Street, 2014–15
In 2014, Rice Building Workshop was invited to design a space to house the Project Row Houses archive. The design was for a storefront in the historic Eldorado Ballroom that would not only address the necessities of storage of artworks and documents, but would also provide space for meeting, research, and exhibition, and also situate the archive within the context of its micro- and macrocommunity. This was a two-semester design-and-build project that resulted in a much-needed archiving and curatorial space for PRH.

THE RICE BUILDING WORKSHOP (RBW) was founded, in 1996, as an outreach program of the Rice University School of Architecture, by professors in practice Danny Samuels and Nonya Grenader, at the instigation of Dean Lars Lerup. Dean Sarah Whiting continued her support of RBW beginning in 2010. In 2017, RBW was renamed Construct, co-directed by Samuels and assistant professor Andrew Colopy.

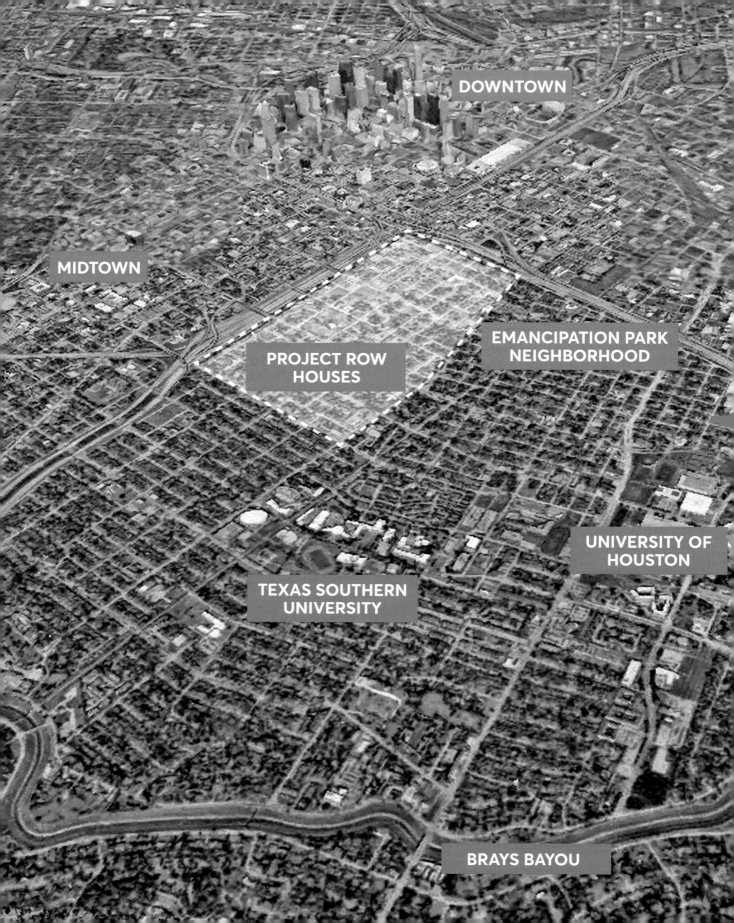

DOWNTOWN

MIDTOWN

PROJECT ROW HOUSES

EMANCIPATION PARK NEIGHBORHOOD

UNIVERSITY OF HOUSTON

TEXAS SOUTHERN UNIVERSITY

BRAYS BAYOU

Neighborhood Development and Art-Based Community Making

George Lipsitz

The median yearly income of residents in the parts of Houston's Third Ward neighborhood served by Project Row Houses (PRH) is $22,948, far below the Harris County median of $53,822. Twenty-one percent of those actively engaged in seeking work in the area are unemployed, while 38 percent of the residents over the age of sixteen are not in the labor force due to disability, retirement, or other causes. Of the more than 762 million square feet of land in the Third Ward, more than three million square feet currently sit vacant. Problems with flooding in the area are exacerbated by the impermeable solid concrete used on city streets, sidewalks, and nearby highways, while local thoroughfares lack sidewalks, trees, and bike lanes.[1]

This profile is not one that promotes residents' access to assets that can appreciate in value and be passed down across generations. It is not a profile that attracts outside investment for the neighborhood as it is now constituted. Rather, this is a picture of a place designed to function largely as an urban sacrifice zone filled with nuisances, hazards, vacant lots, and few businesses. Yet the proximity of the Third Ward to downtown Houston, the tax incentives available to developers, the new city expenditures upgrading Emancipation Park, and—most of all—the success of Project Row Houses in building vibrant, creative, and attractive community spaces and practices have made the area an unexpected success, yet for that very reason, also an area vulnerable to a process of gentrification that would displace current residents and strip the neighborhood of its historical social meanings and use value.

Collective action by neighborhood residents brought Emancipation Park into existence in 1872. Formerly enslaved people living as free black citizens of Houston pooled together their money to purchase ten acres of land for use as a park where they could celebrate their freedom during annual festivities on Juneteenth, and where they could congregate convivially the other 364 days of the year. That commitment to collective action continues today in many forms. It led neighborhood residents, in 2017, to persuade the city to change the name of one of the streets that borders on the park from Dowling Street (named in honor of an officer in the proslavery Confederate army) to Emancipation Avenue.

An ethic of collaboration and co-creation endures in all of the diverse activities carried out by Project Row Houses to promote economic growth and democratic development without displacement. In conjunction with its many

Aerial view of northern Third Ward showing the geographic territory of Project Row Houses

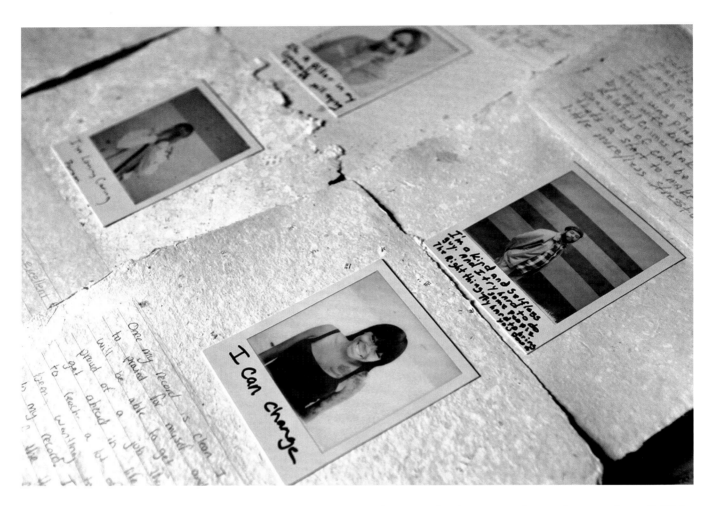

People's Paper Co-op, Courtney Bowles and Mark Strandquist, *Transforming the Narrative of Reentry*, 2016. Round 44

community partners in the Emancipation Economic Development Council, PRH envisions a neighborhood filled with permanently affordable housing under the control of—and accountable to—community residents; an area where vacant lots become loci for a wide range of public practices and activities; a part of Houston where bioswales, trees, and gardens work in concert with permeable surfaces to soak up and purify storm waters and prevent flooding. These ambitious plans flow organically and credibly from the quarter century of successful artistic, social, and economic development projects that have coalesced at PRH, notably the Young Mothers Residential Program, the Public Art Program, and the successful restoration and development of affordable housing units and pocket parks, as well as venues for exhibiting art, listening to music, and playing dominoes.

Art-based projects can be key factors in neighborhood revitalization and community development. Most working people have only horizontal networks that link them to other similarly situated persons. Community-based art projects contain the potential for vertical connections, for bringing differently situated people to a neighborhood, and for enabling residents to forge complex connections outside it. The Social Impact of the Arts Project at the University of Pennsylvania, School of Social Policy and Practice, in Philadelphia, has

discovered that high rates of cultural activity in low-income neighborhoods reduce youth delinquency and school truancy because they promote collective community efficacy and create a level of social cohesion that makes residents feel secure in place and willing to act on behalf of the common good.[2] The mutual respect and affective support at the heart of social cohesion even exerts an influence on physical health by reducing wear and tear on metabolic systems.[3] Yet social cohesion is difficult to start and daunting to sustain inside a winner-take-all global economy that increasingly invests resources in favored places deemed as exceptional, while relegating places like the Third Ward to the status of the disposable. Economic deprivation today takes the form of increasingly irregular and insecure low-wage work, the destruction of the social safety net, and the stagnation of real wages despite increases in worker productivity. In the two decades preceding 2016, financial institutions increased their profits by as much as 400 percent, while in the first ten years of the twenty-first century alone as much as $750 billion was shifted from labor to capital.[4] Under these conditions, the strategies for community-led regeneration in the Third Ward advanced by PRH and the formation, in 2015, of the Emancipation Economic Development Council are crucial to the survival of the neighborhood, its residents, and its unique social, cultural, and historical character.

Most art-based community development efforts proceed from the top down by favoring members of what urban studies theorist Richard Florida has famously designated as the "creative class."[5] This form of development routinely provokes gentrification and exacerbates inequality. PRH seeks another path, recognizing that the many different kinds of creativity that people possess can be the basis for a bottom-up approach to development, without displacement, which carefully cultivates a capacity for collective efficacy, social cohesion, and democratic self-determination. Project Row Houses' activities have attracted highly skilled and widely recognized artists, to be sure, yet at the same time it has promoted opportunities for a wide range of carpenters, electricians, graphic designers, cooks, teachers, accountants, counselors, van drivers, and childcare professionals. Since 1996, the Young Mothers Residential Program has created value for the neighborhood by identifying single mothers trying to finish their educations while raising children, recognizing them as a great community resource, rather than a problem population. The program's success in helping women get college degrees by providing subsidized housing while they are in school has created a cohort of professional women who have returned to the neighborhood to help sustain and lead it. This practice of viewing what seem to be liabilities as potential assets informs nearly all of PRH's work. In its study of the potential for development in the Third Ward, for example, the MIT CoLab notes that the vacant lots widely viewed as without positive value can become sites for temporary and even fugitive enterprises and practices such as tutoring sessions, community meetings, pop-up shops, food trucks, home-purchasing tutorials, community gardens, farmers' markets, and public meetings.[6] Those lots could also serve as places for generating solar power to be used in the neighborhood and sold at a profit to outsiders as the Franklin District Project in Sacramento has demonstrated.[7]

Finding value in undervalued objects, places, and people flows organically from PRH's history of artistic practice and its commitment to viewing the project as more of a creative act than a producer of created objects, as a living social sculpture rather than an ideal physical environment. When PRH co-founder Jesse Lott introduces newcomers to the mission of the organization, he places an empty one-gallon plastic milk jug on a table. "What do you do with this when it's empty?" he asks. The ecologically minded respondents answer that they would recycle the object, while others say they would simply throw it away. Speaking for himself and for the other artists and activists central to the work of PRH, Lott has another answer: "If we pay three dollars for a container of milk," he explains, "we have to find a way to turn the empty jug into twenty dollars' worth of art."[8]

Lott's illustrative anecdote encapsulates important dimensions of the work performed by PRH. Individuals and communities lacking resources must develop creative ways of being resourceful. Finding value in discarded and abandoned objects can help cultivate the capacity to discern and deepen the latent, but as yet unrealized, value in undervalued places and undervalued people. Seeing the potential in an empty plastic milk jug requires a parallel kind of vision, an ability to see the "what can be" hidden inside the "what is." This parallel vision has enabled PRH to turn abandoned shotgun houses into

Salvaged materials in the studio of PRH founding artist Jesse Lott, 2017

Jesse Lott in front of his work, ca. 2005

valued works of art; to see an often marginalized, forgotten, and systematically abandoned Third Ward neighborhood as an endlessly changing, collectively created, social sculpture; and to deploy artistic practice as a focal point for community economic development and political self-determination.

Lott first formulated his ideas about art as a form of community action while teaching sculpture, in the early 1980s, to a group of young mothers in the Fifth Ward.[9] The women lacked the money needed to purchase materials to sculpt, so Lott selected paper as the appropriate medium for their work. He explained his theory: "If you feed your baby cereal and milk, after you finish the cereal you can take the box and make a piece of sculpture that's worth more than the cereal and the milk."[10] This process enabled the women to produce works of art, but even more important, it built a sense of personal and collective efficacy. From Lott's perspective, this creative deployment of everyday objects as raw materials for artistic creativity "helps you get beyond whatever limitation it is that keeps you from being productive. So it allows you to go here, instead of stopping—pow—I gotta go to the store, I gotta go back to work, I gotta dip into my piggy bank, I gotta do such and such, before I can get into the pure enjoyment of creative expression."[11]

Anyone who has had the privilege and pleasure of viewing the art pieces that Lott creates knows that he lives by the words he speaks. He collects discarded and devalued objects and turns fragments of their wire, wood, paper, plastic, and metal components into raw materials for sculptures and collages. Discerning the "what can be" ensconced inside the "what is" enables Lott to perform miracles. His wire sculptures, for example, bring the art of drawing beyond the page to instead inscribe it in space. Responding to an observation he once heard that the space for drawing is by nature illusionary because drawings cannot leave the page, Lott challenged himself to achieve the impossible, to "develop a technique in which you could take a line, follow it through real space and allow it to present the illusion that you would get from a drawing and the reality that comes with a piece of sculpture."[12]

The ethos of parallel vision that Lott prescribes permeates the work that takes place at Project Row Houses. During their residency at PRH, in 2016, artists Courtney Bowles and Mark Strandquist, collectively known as the People's Paper Co-op (PPC) of the Village of Arts and Humanities, in Philadelphia, recruited trained legal practitioners to work successfully with Third Ward residents to remove from police records cases that did not result in convictions. These records of arrests and charges but no convictions can haunt legally innocent people because they are used to deny them housing, employment, and other necessities. The project also entailed participants tearing their criminal record to shreds and transforming, through a hand-paper-making process, their record into a blank sheet of paper. Participants then made statements and a Polaroid portrait (a reverse mug shot) in response to the question, Without my record I am free to be . . . ? Their photograph and writing were then embedded into their pulped criminal record. As the new sheets dried, they were added into the PPC's installation that included the transformed records of hundreds of past participants. The hanging sheets created the shape, form, and size of a

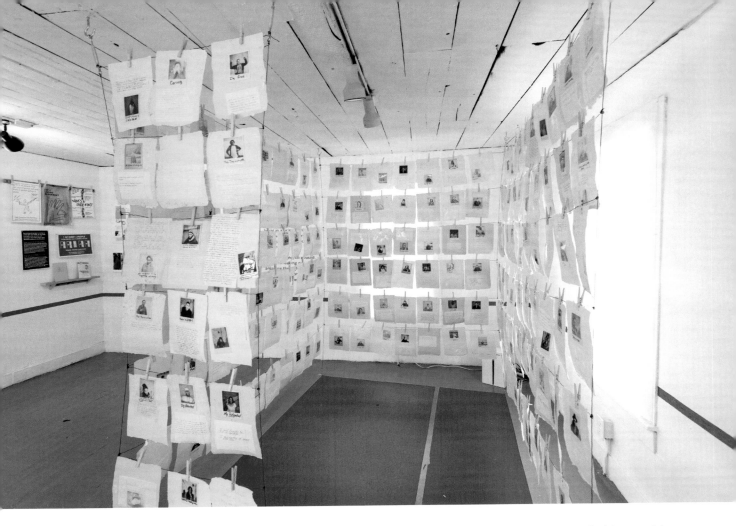

People's Paper Co-op, Courtney Bowles and Mark Strandquist, *Transforming the Narrative of Reentry*, 2016. Round 44

prison cell. The shredded criminal records were also recycled into writing paper distributed to neighborhood residents, along with envelopes and stamps, so they could communicate with relatives, friends, and loved ones in prison.[13] The same paper that has the power to hold people back because nonconvicted criminal cases are recorded on it can be shredded into works of art and recycled as writing paper used to reconnect incarcerated people with their friends and loved ones.

This act of inversion—of turning poison into medicine, of transforming humiliation into honor, of making dead-end situations into openings—resonates with the philosophy and practice of PRH that consistently cultivates collective capacities for creating value. Like the symbol of caduceus (two snakes entwined around a stick) that physicians of antiquity deployed to connote that the things that kill can also cure when reconfigured in the proper ways, PRH starts with the unglamorous and sometimes perilous "what is" in order to forge the emancipatory "what can be." The very row houses that serve as the emblem of the project exemplify this process. Designed and built by newly freed people after the emancipation according to principles originally developed in Africa, these dwellings turned multiple forms of disadvantage into advantage. Challenged by the limited supply of building materials, the high

costs of land acquisition, policies that based taxes on the width of buildings, and relentless segregation that crowded black people into small pockets of the city, newly freed black people constructed narrow but deep houses on small lots, configuring the rooms so that breezes flowed through unimpeded during the hot Houston summers, while accenting the regular patterns of copper roofs and eaves with customized decorations near front doors and on porches that honored both similarity and difference. The residents of those dwellings performed miracles inside them: the miracle of black survival, the miracle of black humanity, and the miracle of black democracy inside a society premised on black subordination and suppression. Today, when a new round of alchemy and conjuring has changed the name of the street bordering Emancipation Park from Dowling Street to Emancipation Avenue, new miracles are being constantly envisioned and enacted.

NOTES

1 MIT CoLab, *Emancipation Park Neighborhood: Strategies for Community-Led Regeneration in the Third Ward*, prepared for the Emancipation Economic Development Council, June 2016, 15, 94.

2 Mark J. Stern and Susan C. Seifert, "From Creative Economy to Creative Society," *Penn Libraries Scholarly Commons*, May 2, 2017, https://repository.upenn.edu/siap_revitalization/6/.

3 Ichiro Kawachi et al., "A Prospective Study of Social Networks in Relation to Total Mortality and Cardiovascular Disease Incidence in Men," *Journal of Epidemiology and Community Health* 50 (1996), 245–51.

4 George Lipsitz, "Making Black Lives Matter: Conjuring and Creative Place-Making in an Age of Austerity," *Kalfou* 4, no. 1 (Spring 2017): 40–58, especially 52–53.

5 Richard Florida, *Cities and the Creative Class* (New York: Routledge, 2005).

6 MIT CoLab, *Emancipation Park Neighborhood*.

7 Jesus Hernandez, *The Franklin Plan: Using Neighborhood-Based Energy Efficiency and Economic Development to Implement Sustainable Community Development Principles*, JCH Research, Sacramento, California, December 2016.

8 This description of Jesse Lott's practice was related to me by Rick Lowe on January 25, 2014, as he drove me to a tour of Lott's studio.

9 Jesse Lott, telephone conversation with the author, May 27, 2018.

10 Molly Glentzer, "Jesse Lott Always Has a Hand in the Action," *Houston Chronicle*, November 4, 2016, https://www.houstonchronicle.com/entertainment/article/Jesse-Lott-always-has-a-hand-in-the-action-10594526.php.

11 Glentzer, "Jesse Lott Always Has a Hand in the Action."

12 Glentzer, "Jesse Lott Always Has a Hand in the Action."

13 Priscilla Frank, "How Artists are Using Row Houses to Empower Citizens in Houston," *Huffington Post*, April 20, 2016, https://www.huffingtonpost.com/entry/project-row-houses-houston_us_5717a1f6e4b0060ccda5090a.

25 Actions

at PRH and beyond

1992

PRH Founders Have A Vision of Art for Social Change

The work of Project Row Houses began when seven visionary African American artists—James Bettison (1958–1997), Bert Long Jr. (1940–2013), Jesse Lott, Rick Lowe, Floyd Newsum, Bert Samples, and George Smith—recognized real potential in a block and a half of shotgun houses at the corner of Holman and Live Oak in Houston's Third Ward. Lowe, while volunteering at S.H.A.P.E. Community Center, joined a tour of Third Ward with community leaders and city officials and brought the houses to the group's attention. Where others saw poverty, these artists saw a future site for positive, creative, and transformative experiences. Together, they began to explore how art might be an engine for social change.

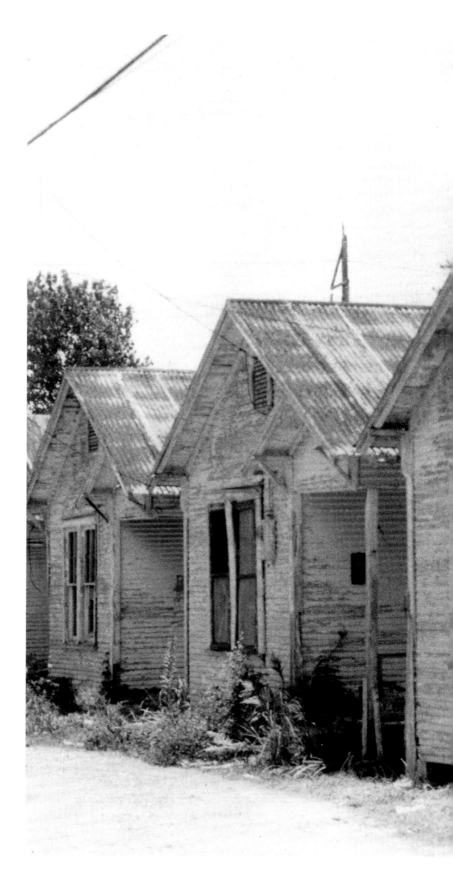

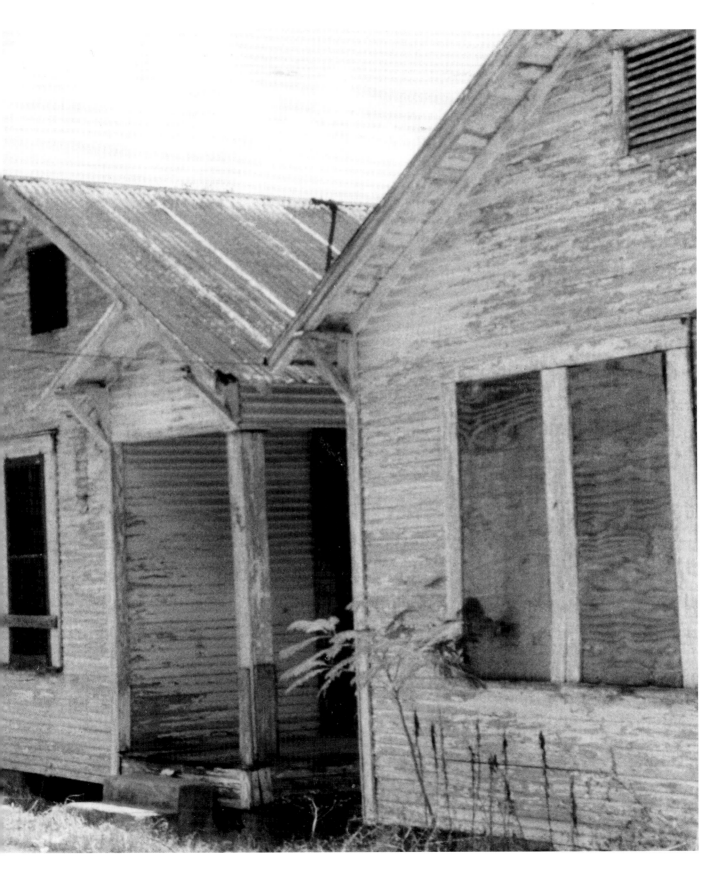

1993

Citywide Support Emerges for Socially Engaged Art Project

After purchasing the block and a half of houses, the founding artists gathered volunteers to restore them. Arts organizations throughout the city, including the Menil Foundation and DiverseWorks, banded together alongside people of all ages to help the artists and the community realize a vision and restore the houses to their former glory. As the renovations continued, PRH garnered more and more attention and support as an innovative, socially engaged art project.

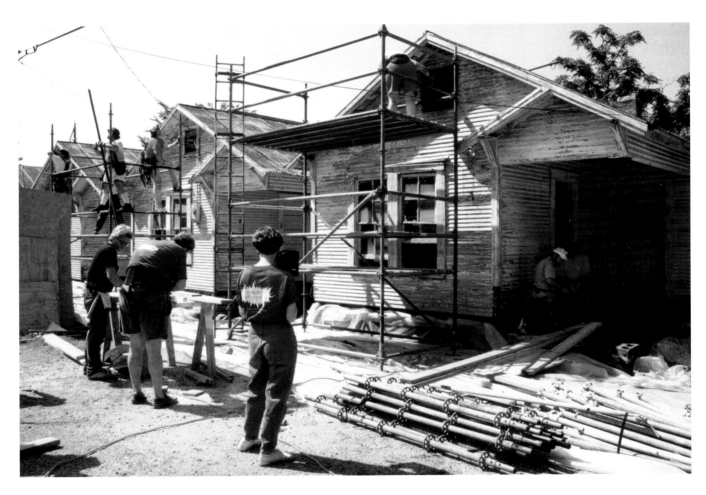

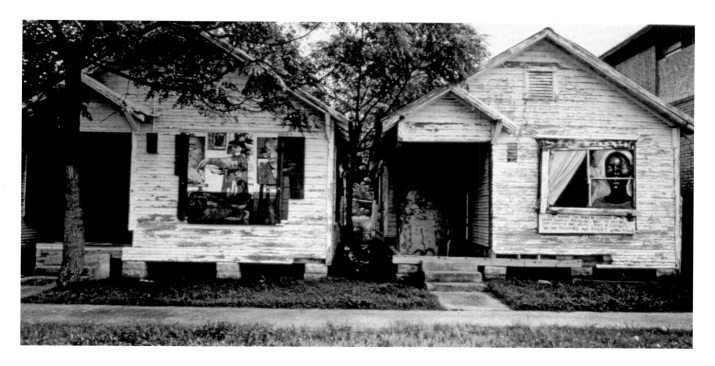

1993

Drive-By Exhibition During Renovations Leads to PRH Art Program

During the renovations, the founding artists began to focus on how they could infuse a visible artistic presence in the project and the neighborhood. With the windows and doors still boarded up, Jesse Lott conceived the *Drive-By* exhibition, inviting artists to create installations on the exterior of the houses. This tradition of inviting artists to install works in and around the houses evolved into what are now referred to as Artist Rounds. Today, the Art Program has grown to include commissioned projects, residencies, and fellowships that engage artists in the PRH model for preserving identity, history, and cultural richness.

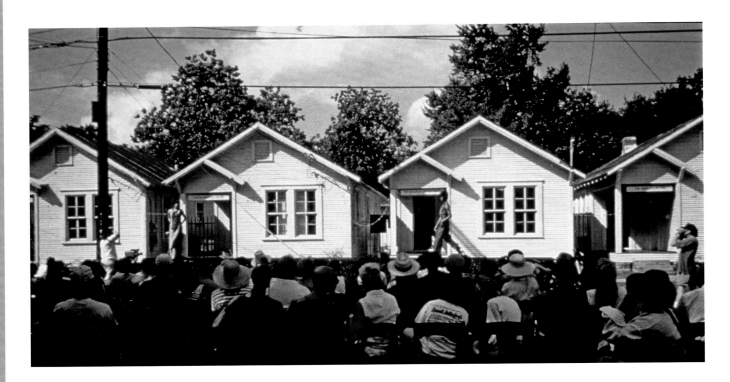

1994

PRH Expands Notions of Art and Community

On October 15, 1994, PRH hosted the opening for Round 1, officially beginning its Artist Rounds. The inaugural installations featured works by Steve Jones, Annette Lawrence, Jesse Lott, Tierney Malone, Vicki Meek, Floyd Newsum, and Colette Veasey-Cullors, in collaboration with David McGee and the Roots Collective—all prominent Texas-based African American artists.

Over the past twenty-five years, PRH has engaged hundreds of artists from all walks of life by inviting them to exhibit their work together and engage the community, collapsing notions of high art and low art. By operating within these broadened concepts, PRH has been able to focus on the impact art has on a community, and to expand its vision of art as a catalyst for social change.

1995

Education Program Becomes A Creative Outlet for Neighborhood Youth

Because PRH operates as a functional member of its community, many of its programs developed as a response to needs observed and yearned for in the Third Ward. Both artists and staff noticed a growing number of youth hanging out in the area with little to do and a need for a creative outlet. In response, PRH created the Arts Education Program.

Working with artists in the community, PRH developed an arts-based curriculum to provide

both an educational experience and a safe space for children to gather after school. The program gives community youth an opportunity to explore their creativity, which allows for a free and open discovery of a logic where failure is taken off the table. Through arts education, youth develop creative connective tissue that expands their view of other academic subjects—and of their lives.

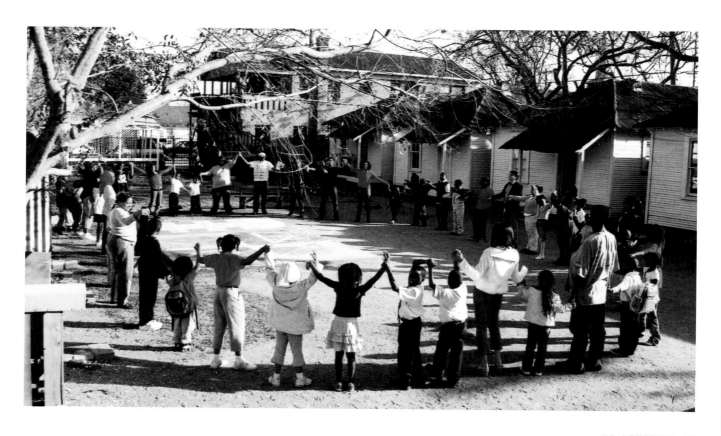

1995

Young Mothers Residential Program Established

In 1995, PRH found an opportunity to support young, single mothers in the community. A growing number of women were having children at an early age, disrupting their educational and career pursuits as they struggled to maintain their day-to-day lives. Through the efforts of a small group of early champions, the Young Mothers Residential Program (YMRP) was established, and the first group of women was invited to move onto the PRH site in January of 1996.

The purpose of YMRP is to empower low-income single mothers and their children in achieving independent, self-sufficient lives. Through this program, PRH provides a culturally rich environment in which residents develop healthy, holistic living practices and cultivate a sense of positive energy and self-worth to guide them in becoming empowered, self-confident, nurturing women, mothers, daughters, and companions.

Since its founding, over seventy families have participated in the program. Women have gone on to pursue doctorate and law degrees or become business owners and community leaders. Some of the greatest success stories are still being told as children from early families enter universities and work toward their dreams.

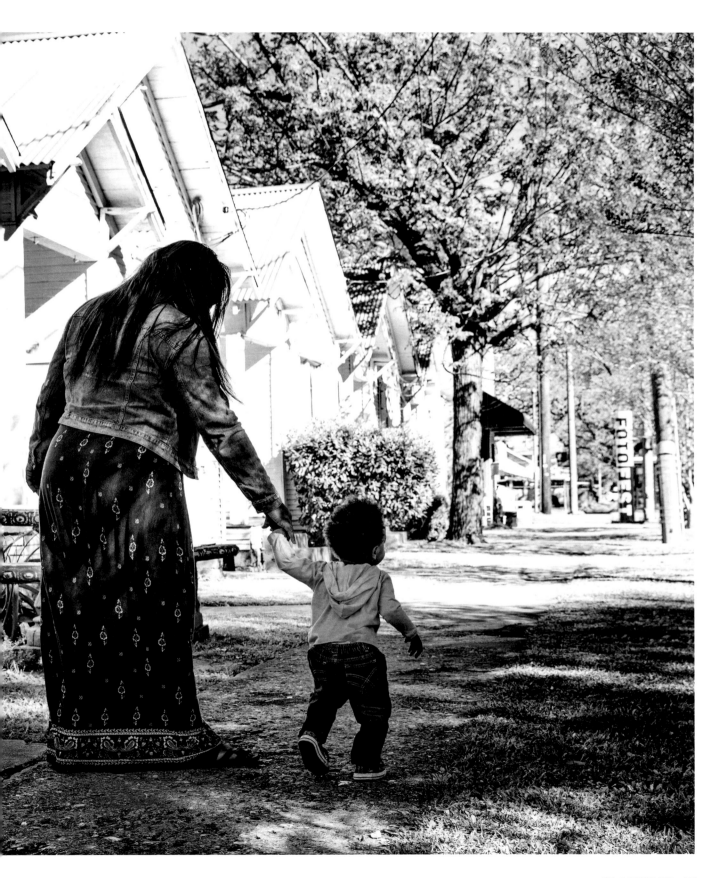

1995

Whitfield Lovell Installation at PRH Incorporates Images of "Anonymous" Blacks

Whitfield Lovell is a contemporary African American artist known for his crayon drawings of African Americans from the first half of the twentieth century, which appear on paper or wood, or sometimes, as at PRH, directly on walls. In 1995, Lovell was invited to participate in Round 3 of the PRH Artist Program. For his installation *Echo*, Lovell formulated ideas of incorporating historic, vernacular photographs of black people as sources for portraits in his work. This method developed by Lovell at PRH has sustained his practice for over twenty years: "At the time I wanted to explore installation further but wanted the right circumstances to arise. When I was approached to do a row house it was just the right time. The feeling in the house was ideal for trying new ideas related to my interest in old photographs of 'anonymous' people."

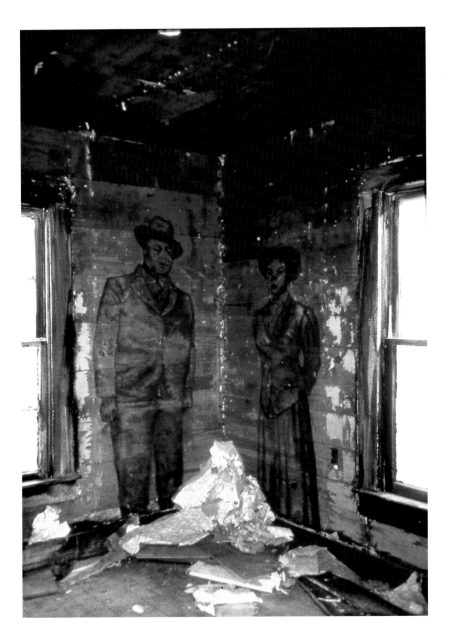

1997

Rice Building Workshop Uses Row House Architecture to Invigorate Neighborhood

Rice Building Workshop, a program for architecture students at Rice University guided by Nonya Grenader and Danny Samuels, has been a long-term collaborator in the PRH community. The earliest collaboration, Six-Square House, a two-story, 900-square-foot home designed and constructed by students, is inspired by the architectural and urban lessons of the original row houses. This project grew into a series of collaborations across the PRH community that all explore the row house model, and strive to show its relevance within modern architecture.

Dr. John Biggers, one of the artists who inspired PRH's founders, said of the row houses, "I see them as I walk the Third Ward of Houston, the rhythm of their shadows, the square of the porch three over four like the beat of a visual gospel." The architecture of these houses has proven to be both poetic and functional—efficient in their use of space and community oriented as they offer an invitation forward.

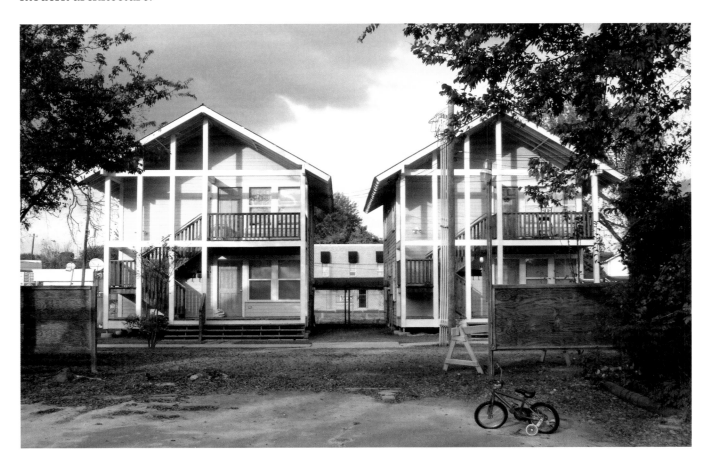

1999

Gift of Historic Eldorado Ballroom Expands Project Row Houses

In 1999, Hubert Finkelstein gifted the historic Eldorado Building to Project Row Houses. Residing on the corner of Elgin and Dowling (now Emancipation Avenue), the building was constructed, in 1939, by renowned Houston architect Lenard Gabert, who designed many of the city's large art deco structures. In its heyday, the Eldorado Building was owned by Anna Dupree, who opened the building in the 1940s with the hopes of establishing a community entertainment venue for black social clubs and other Third Ward groups. The first floor of the building hosted a series of businesses that operated out of storefronts, and helped activate the neighborhood.

The building also houses the Eldorado Ballroom, which occupies the second floor of this massive structure. Until being closed in the 1970s, the ballroom hosted countless blues and jazz performances, weekly talent shows, and sock hops. Texas-born musicians such as Sam (Lightnin') Hopkins and Johnny (Guitar) Watson honed their skills in the ballroom and went on to bigger careers. Many internationally known jazz and bluesmen, including B. B. King and Count Basie, would make regular appearances as they passed through town. In May 2003, the Eldorado Building re-opened for its first major event in thirty years. Today, the building hosts small businesses incubated by Project Row Houses, as well as the PRH archive.

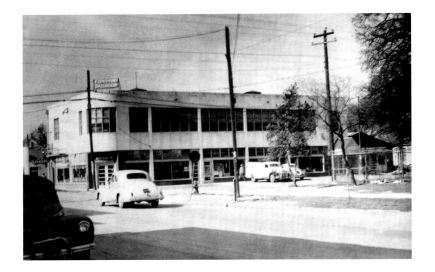

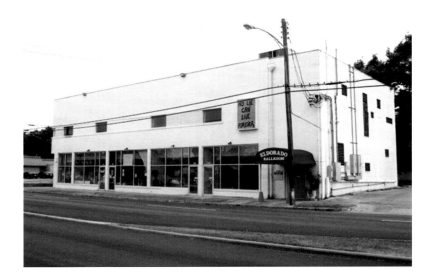

2004

The Flower Man Turns Junk to Pretty

Known by many as the Flower Man, Cleveland Turner was a local legend in Houston who spent seventeen years homeless. One day Turner was found on the street, almost dead, and rushed to the hospital. During his stay, Turner had a vision: "It was just junk, like a whirlwind going around and around, and it was just going up so high . . . pretty, pretty, pretty." It was then that he vowed to have this vision come to fruition.

As Turner rode through Houston on a bicycle adorned with flowers (earning him the moniker Flower Man), he collected items cast aside by others and arranged them on his lawn and in his home. Around 2003, Turner moved into a house on the PRH site, where he continued his practice until his death in 2013.

2005

Esther Mahlangu Paints Ndebele Patterns in Texas

Esther Mahlangu was invited to PRH for an immersive three-week residency in 2005. Mahlangu is part of the community of Ndebele people in the Transvaal, located north of Pretoria, South Africa, whose members continue to practice centuries-old art forms. The decorative wall paintings of the Ndebele are associated with ritual ceremonies and painted exclusively by women who pass the techniques and motifs down to their daughters. During her residency, Mahlangu created four outdoor murals that served as an entryway into a residential space, and were installed on the PRH site for over a decade.

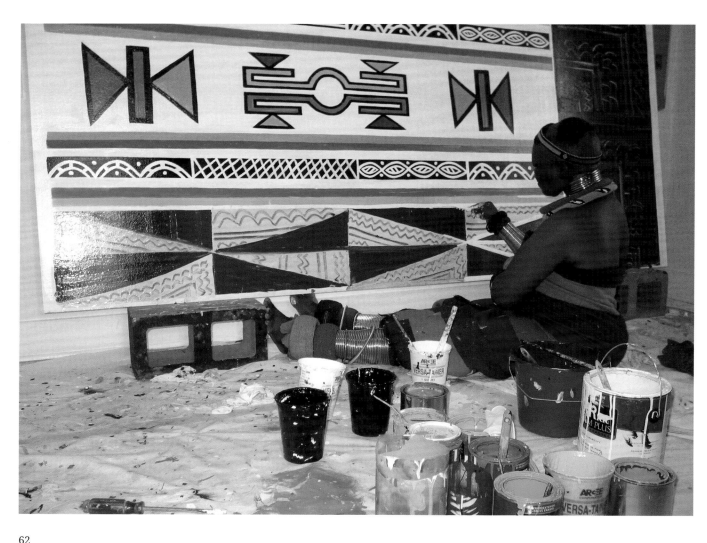

2006

Bert Long Jr.'s *Field of Vision* Finds a Home at PRH

The sculptural installation *Field of Vision*, by PRH founding artist Bert Long Jr., was originally a cultural enrichment project of the Fifth Ward Community Redevelopment Corporation and the Pleasant Hill Community Development Corporation. The installation was located in Houston's Fifth Ward from 1999 to 2005. From 2006 to 2013, it was reinstalled at PRH to ensure the life and preservation of the artwork. *Field of Vision* provides a point of demarcation to view a multicultural vision. The piece represents the impact on a community when that vision is brought to reality, and makes a strong statement about the power of inclusion. Long states, "As artists, we have the obligation to provide the world with art which communicates as truth; I believe that art has the power to heal our souls of their afflictions."

2008

Quilt by Children in
PRH Education Program
Launches into Space

In 2007 and 2008, astronaut Leland Melvin came to PRH to speak to children in the education program about his life and career, and about opportunities to use creativity in all areas of their future development. Melvin asked the students to create an artwork that he could take to space: they responded by working together to make a quilt, inspired by the work of artist Faith Ringgold, who created quilts and paintings with content that paralleled social issues of the 1960s and 1970s. Thinking about Ringgold's work as an inspiration, the children were asked to imagine fictitious scenarios that would take place in space.

One panel of the quilt shows a neighborhood complete with houses, streets, and citizens. Another panel depicts how Third Ward would look in space, and includes the Eldorado Ballroom and the elementary school that the students attended. The third panel shows a football game, with spectators and concession stands. In the quilt's final panel, ladies shop at a futuristic shopping center. All of the quilt's sections contain a segment of a circle that, when joined together, align to create one planet that unifies the quilt. In 2008, the children's artwork traveled with Melvin on his space flight.

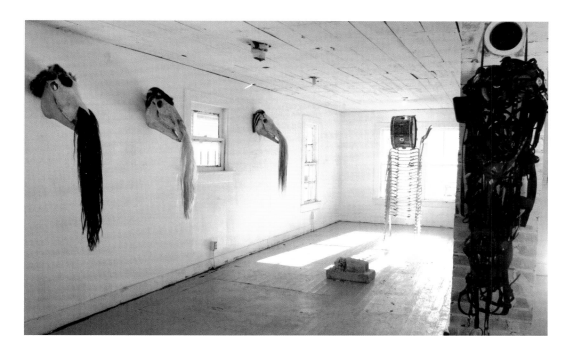

2008

Lightnin' Hopkins Exhibition Leads to Monument at PRH

Philadelphia-based conceptual artist Terry Adkins was invited to organize Round 29 titled, *Thunderbolt Special: The Great Electric Show and Dance* highlighting the work of the musical giant Sam Lightnin' Hopkins. Adkins invited James Andrew Brown, Sherman Fleming, Charles Gaines, and PRH co-founder George Smith to create a multidimensional and multisensory portrait of the musician.

On October 11, 2009, the artists presented the Thunderbolt Special performance, an interwoven variety of music, ritual, spoken word, and video celebrating the life and art of Lightnin' Hopkins. Lone Wolf Recital Corps, Blanche Bruce, The Sacred Order of the Twilight Brothers, and the Anti-Formalist Reclamation Organization were featured, along with the Round 29 visual artists who joined the performance groups.

The Round also addressed the unfortunate truth that, although Lightnin' Hopkins was one of the most prolific and highly acclaimed blues musicians in the world, having recorded approximately 120 albums during his lifetime, there was not a single monument or plaque in his adopted city of Houston. The artists began a public campaign to remedy this oversight, creating proposals for permanent public memorials that could be erected at various sites in Houston. These proposals were placed in the PRH archive and are available to the city for future projects. As a result of this Round, a historic monument to Hopkins was erected by the City of Houston on-site at PRH at the corner of Emancipation and Francis Avenues.

2010

Black Panther Exhibition Honors Third Ward

In 2010, artist william cordova organized an exhibition at PRH's Eldorado Building focused on the contribution and sacrifice made by Carl B. Hampton, a Houston Black Panther leader and People's Party II chairman. The exhibition, appropriately titled *Black Panther*, also served as an opportunity to work with other artists and activists in Third Ward, and to fundraise for a headstone for Hampton's burial site. The artists who participated in this exhibition included: Regina Agu, Dawolu Jabari Anderson, william cordova, Nathaniel Donnett, Emory Douglas, Robert Hodge, Steffani Jemison, Ayanna Jolivet Mccloud, Robert Pruitt, George Smith, Kaneem Smith, and Keijiro Suzuki. The exhibition and fundraiser proved to be successful in honoring the history of Third Ward, the legacy of Carl B. Hampton, and the power of collectivity and cultural preservation.

2012

A Row House Appears in Houston's Art Car Parade

The Art Car Parade, hosted by the Orange Show Center for Visionary Art, has been a staple of Houston creativity since the parade's beginnings in 1988. In 2012, the Orange Show, a historic collaborator with Project Row Houses, invited PRH to participate. Under the guidance of PRH's jack-of-all-trades Jimmie Jones, youth in the community constructed a row house around the exterior of a van. When driven in the parade, PRH's art car showcased an architecture prevalent in Third Ward, and highlighted the community-based work being done by the organization.

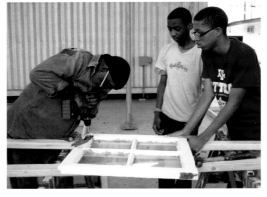

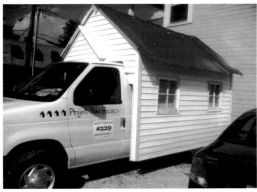

2013

PRH Celebrates 20 Years with *Social Practice.Social Justice* Symposium

In celebration of its 20th anniversary, PRH hosted *Social Practice.Social Justice*, in January 2014, a weekend-long symposium organized by Ryan N. Dennis, curator at PRH. Opening with a conversation, moderated by curator Valerie Cassel Oliver, featuring Rick Lowe, Theaster Gates, and Mark Bradford—three African American artists with community-oriented, socially engaged art practices—the symposium focused on the founding principles of PRH. The event featured long-term collaborators, as well as those impacted by programming at PRH. A series of engaging talks and panel discussions highlighted the principles that help PRH not only to enter community, but to forge it.

2013

Sean Shim-Boyle Reimagines a Row House Chimney

In 2013, on a visit to Los Angeles, Rick Lowe became aware of artist Sean Shim-Boyle, who presented deep enthusiasm and the promise of thoughtful artistic production. Shim-Boyle was invited to participate in Round 38, and instantly gravitated toward the architecture of the shotgun art houses. Drawn to the chimney and its function of being once used to cool the house, Shim-Boyle created *Salt House* to highlight the chimney at the center of the row house by iterating a more imaginative brick column as counterpoint. This work focused attention back on to that original gesture of site—home and commerce, private and public, gender and race.

The installation's title, *Salt House,* derives from the artist's ongoing research into the quality of the row houses' existing brick chimneys. The closest approximation to its characteristics was used to produce the installation. According to the artist, the title "alludes to memories of commerce and domesticity—the preservation of food—expanding outward to religion, and myth, and the luck to be obtained by throwing salt over one's shoulder."

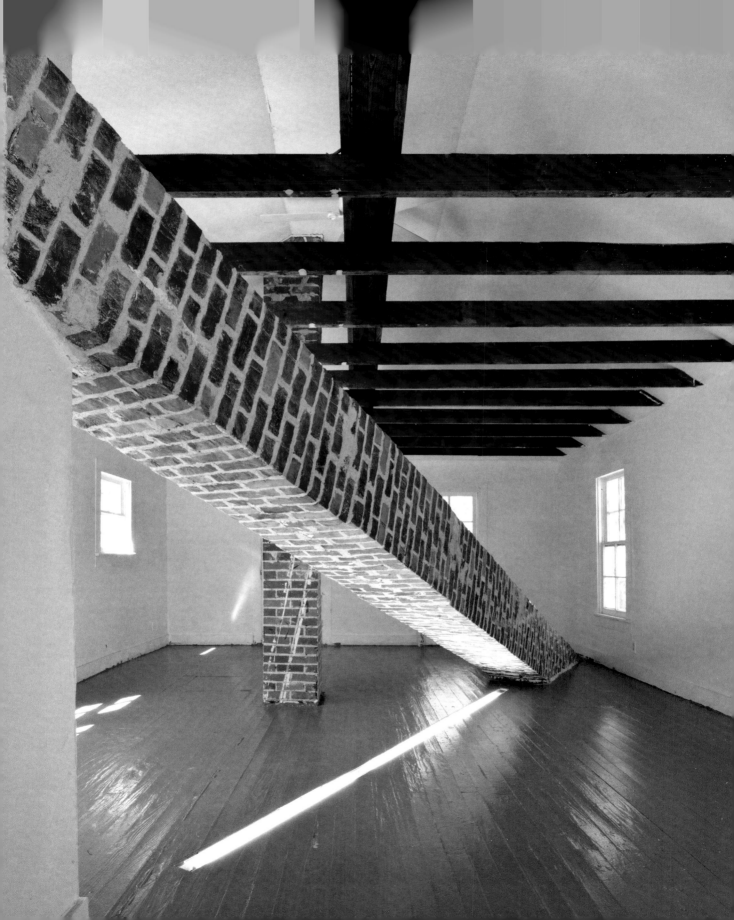

2014

PRH Founding Artist Rick Lowe Named a MacArthur Fellow

After twenty years of working in the Third Ward, PRH founding artist Rick Lowe was honored with a John D. and Catherine T. MacArthur Foundation Fellowship, commonly referred to as the MacArthur "genius" grant. In those two decades, PRH had become a notable project and organization recognized internationally as both innovative and ambitious. Through his work with Project Row Houses and in the Third Ward, Lowe has invited artists to engage the community, to share and to learn, and then to move on to begin their own projects. Lowe has taken the practice of social sculpture—a term coined by

artist Joseph Beuys that influenced the development of PRH—to work with communities and artists around the world, sharing what he's learned from the experiences of PRH.

In regard to being referred to as a "genius," Lowe told *Art in America*: "Genius unfolds when simple actions come together at the right time and manifest themselves in ways that are powerful. To me it doesn't carry with the person—it's the context in which the person acts which allows 'genius' to unfold."

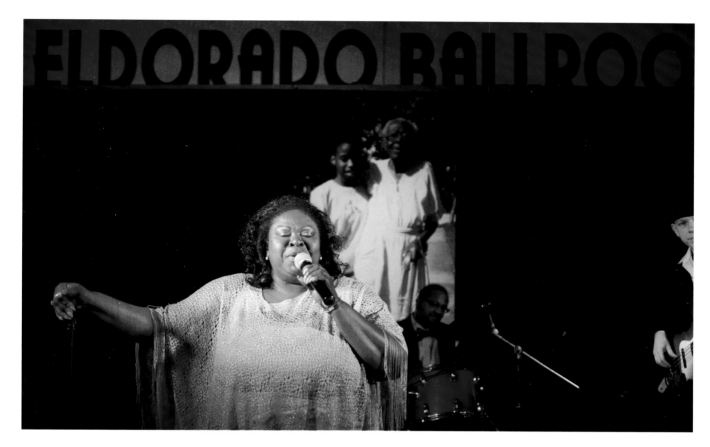

2014

Live at the Eldorado Reverberates with Sounds of Blues and Jazz

Live at the Eldorado sought to stimulate and recapture the energy of the historic Eldorado Ballroom, a Houston counterpoint to the more famous Savoy Ballroom in Harlem. The Eldorado Ballroom billed itself as the "Home of Happy Feet"—signifying not only its reputation for lively musical performance but also its large, and reportedly often crowded, dance floor.

Numerous Houston musicians received valuable professional experience early in their careers by playing in the Eldorado Ballroom house bands. Many subsequently became famous band leaders and recording artists in their own right: saxophonist and vocalist Eddie Vinson, saxophonist Don Wilkerson, and trumpeter Calvin Owens.

On May 2, 2014, Milton Hopkins and Jewel Brown took to the stage of the Eldorado Ballroom and reinvigorated the rich tradition of this venerable space. Both artists hold a strong connection to the Ballroom, having performed there throughout their careers alongside other legends of blues and jazz.

2014

Sign Painters Contribute to the Vernacular Spirit of Third Ward

In 2014, the Houston-based collective Otabenga Jones & Associates participated in Round 40, *Monuments: Right Beyond the Site*, which examined the strategies traditionally used by African Americans to mark, beautify, or commemorate public and private spaces in Third Ward. The artists took over all seven of the art houses to highlight historic African American histories and events at the former Lanier East Hall Men's Dormitory at Texas Southern University, the Progressive Amateur Boxing Association, the People's Party Clinic, Unity Bank, and Blue Triangle YWCA. One house was dedicated to Third Ward sign painters Israel McCloud, Bobby Ray, Walter Stanciell, and V. Woodard, who represent an aesthetic traditionally seen in the Third Ward landscape.

Hand-painted signs in Third Ward, used chiefly to promote small businesses and give directions, are so prevalent as to be ubiquitous. The signs are not unique to the area, but they are integral to its self-image. As demographics shift and the neighborhood's physical landscape changes, standard-issue designations from the city, such as "Third Ward" "Midtown," and "Museum District," are weak in their ability to meaningfully signify communities and their history. In these moments of erasure, the language of a people's visual culture—the vernacular, stylistic renderings of the sign painters' art—speaks over the rhetoric of policy. In the words of graffiti artist Rammellzee (a sign painter of a different sort), each letter so written is "armed to stop all the phony formation, lies, and tricknowlegies placed upon its structure."

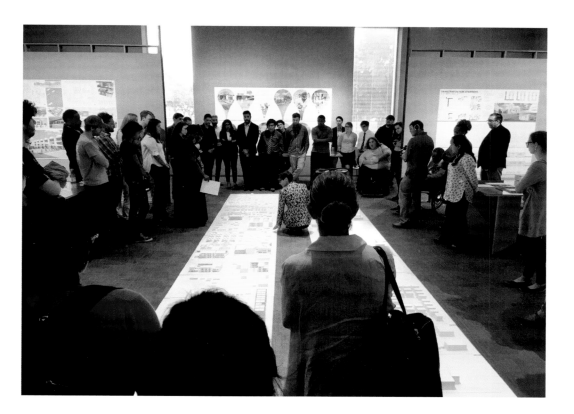

2015

19th-Century Emancipation Park Sparks 21st-Century Emancipation Economic Development Council

Nearly a century and half ago, a group of newly freed African American slaves, led by Baptist minister Reverend Jack Yates, purchased the land where Dowling (now Emancipation Avenue) and Elgin Streets meet, in what became the first public park in Texas, and remained one of the only municipal parks open to African Americans during the era of racial segregation: they named it Emancipation Park. The park has remained a home to Third Ward's annual Juneteenth celebration.

After the park underwent a thirty-three-million-dollar renovation, many in Third Ward felt increased pressures of gentrification. In 2015, PRH gathered with organizations, businesses, and community residents to discuss the future of the northern Third Ward where the park is located. Threatened by the loss of the community's history and culture, this coalition of churches, nonprofits, community development corporations, business owners, artists, and residents joined forces to inspire hope and contribute to the revitalization and preservation of the Third Ward. Together they formed the Emancipation Economic Development Council (EEDC).

2016

PRH Display at the Smithsonian's National Museum of African American History and Culture

In a significant moment for African Americans, the Smithsonian National Museum of African American History and Culture opened its doors to the public on September 24, 2016, offering a representation of the African American experience throughout the history of the United States. As part of its permanent display "Artistry: Craftsmanship and Creativity," the museum features Project Row Houses, giving PRH an honored place in the history of artistic practices by African American artists and their communities, and establishing PRH as an important footprint in this cultural history. The National Museum of African American History and Culture also houses a collection of artworks by African American artists, including paintings by PRH co-founding artist Floyd Newsum.

2017

Project Row Houses' Impact Is Exhibited in Japan

In 2016, Michiko Akiba, a curator and organizer based in Tokyo, visited Project Row Houses to learn more about how the organization functions within the community, and to explore socially engaged art, with its active role in the real world, which was gaining attention across the globe. Akiba observed processes of dialogue and cooperation between people and the artists who sought to engage them.

Socially Engaged Art: A New Wave of Art for Social Change, the resulting exhibition held in Tokyo, in 2017, presented works by artists including Suzanne Lacy, Ai Weiwei, and the founders of Project Row Houses. It was the first exhibition to present this style of art to the Japanese public, while reexamining Japanese art within the context of an engaged art practice.

2017

BWA for BLM at PRH

In 2017, PRH curator Ryan N. Dennis worked with artist Simone Leigh to bring the collective Black Women Artists for Black Lives Matter (BWA for BLM) to PRH for Round 46. The group utilized PRH's seven art houses as a platform to cultivate public dialogues about the issues that impact the lives and movements of black people, and created and organized programs for the general public to get involved with related issues.

"Art is a conduit for us to communicate and have meaningful conversations," says Dennis. "The art houses have always been a beautiful way for us to elevate the conversation around the work happening at a level localized specifically to the Third Ward." This Round allowed PRH to showcase the work of prominent black female contemporary artists. While the comingling of art and activism is not new, providing space for these intrepid women allowed them an opportunity to speak to issues facing Houston's historic African American community of Third Ward.

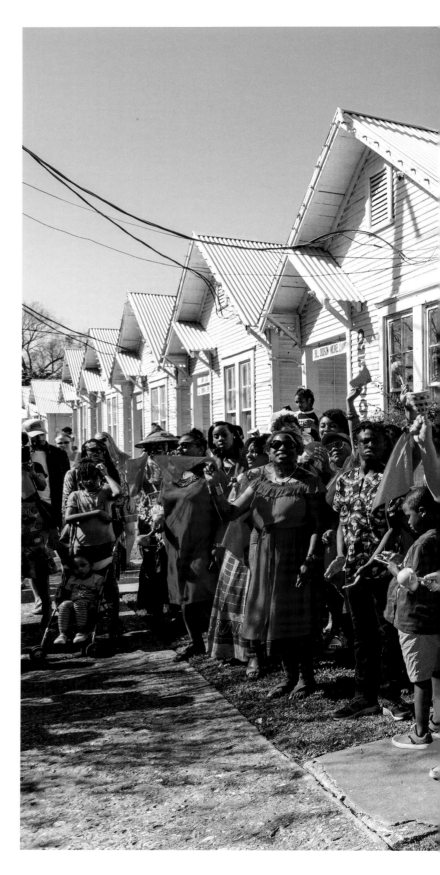

Doing What Is Necessary
and Needs To Be Done:
A Conversation

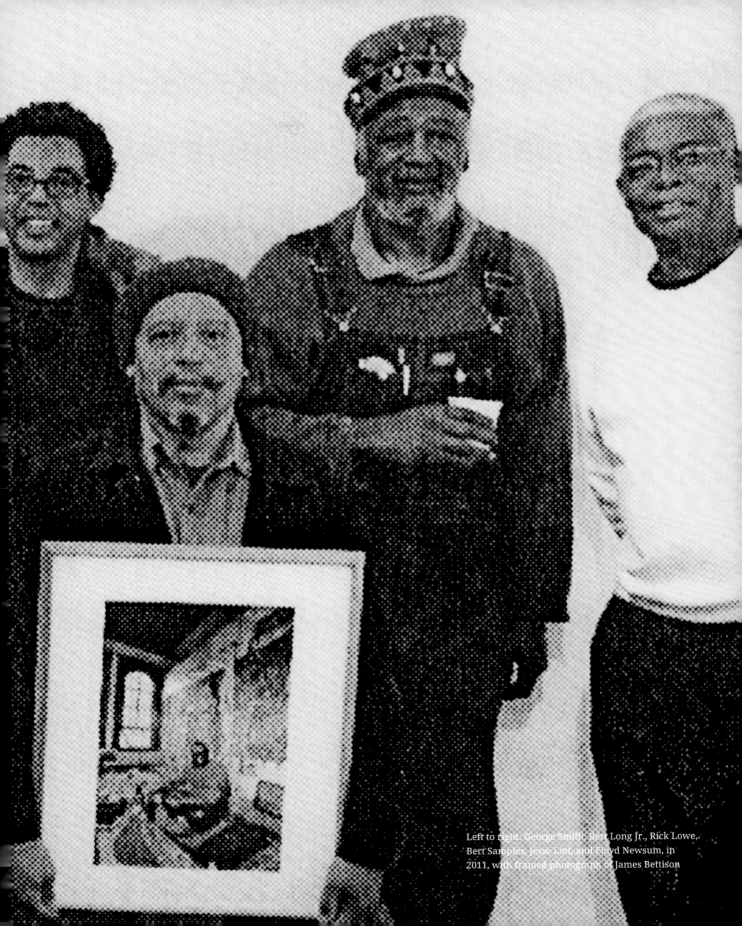

Left to right: George Smith, Bert Long Jr., Rick Lowe, Bert Samples, Jesse Lott, and Floyd Newsum, in 2011, with framed photograph of James Bettison

Project Row Houses emerged, in 1992, from a series of conversations among James Bettison, Bert Long Jr., Jesse Lott, Rick Lowe, Floyd Newsum, Bert Samples, and George Smith—collectively, The Magnificent Seven—who sought ways to support and preserve Houston's historic community of Third Ward. The artists' concerns were: How can we use our collective strengths to support our communities, create new artist opportunities, and forge new models for living creatively, gracefully, politically? In 2011, the six living founding members sat down for a conversation. The result is an oral history, excerpted below, that powerfully recalls the context in which Project Row Houses was formed.

PROJECT ROW HOUSES CAME ABOUT FROM A MEETING JUST LIKE THIS

Rick Lowe: This is something we have been talking about doing for a long time—getting together again, because we used to do this a lot.

Floyd Newsum: From the time that we started coming together, we would have to go to each other.

Bert Long: How did we get together?

Floyd Newsum: I remember we got a show together.

Rick Lowe: Jesse do you remember who put that show together at Midtown, the one that we were all in, the one that had the small gallery only upstairs? Bert is calling that out that it's the first time we all showed together.

Floyd Newsum: Y'all had been established longer than I had.

Bert Long: That was all part of Artists in Action. We started sending out cards for Artists in Action. We would send our business cards out, the people, and anyone that wanted to be part of this group, could send a business card with a picture, or a picture with their phone number. And then, it was basically: I am a member of Artists in Action, when am I gonna have a show? You call five people, and those five had an obligation to show five, and so here is an artist that had never had a show that had five hundred people at their opening. We did that forever.

Jesse Lott: It was the crowd concept.

Bert Long: The crowd concept.

Jesse Lott: It is really a pyramid scheme, a pyramid scheme without having to really risk any money [*laughs*]. All you risk is your presence. You see what I am saying? If you have presence, you got people there, you can make money, but you need to have a crowd in art to get the notoriety. So what we had was a scheme to get a crowd. It was a bait thing, where you would bait them by the previous exhibition, which you tell them what they missed, but it was a

nonexistent exhibition, missed. And you can be at the next one if you registered, and brought people.

Bert Long: And the whole thing was really involved in where you [Floyd] have been a professor forever now at the University of Houston-Downtown. You and I did a show there, and I did a big ice piece inside. In fact, you guys published one of the first posters, and I still have that poster. It's in my archive now. A lot happened between Fifth Ward and Third Ward. For people that don't know: Fifth was Bloody Fifth and then Third Ward was Sadity Town. I was working the Houston clubs, and I had my silk suits with a cane and alligator shoes. And so I would come out here to Eldorado and Club Sadity. You understand? That's where all the jazz was, that is why I knew about the Eldorado, and during those times I could get in anywhere even though I was only sixteen, seventeen. I have always been this size, and I shopped.

THE TIME WHEN WE FIRST GOT TOGETHER

Rick Lowe: So Bert took us to the time when we first got together.

Floyd Newsum: Like we said, we didn't know each other that well. I've known Bert the longest, and I've known Jesse for a long time. When we got together it was an interesting kind of spark. Because the thing I remember was the way we played dominos; I always thought it was very in your face. No one backed down, and if you backed down you weren't gonna hang with that group. I just remember the time after we had that show at Midtown, we came down and sat down on the corner and for some reason—was it Rodney Ellis? —it was some congressman that drove by and you recognized him. This was when I recognized the genius of Jesse, cause Jesse took opportunities to challenge and take it to the next step. We were talking about, "How can we convince the people on the other side of the track to give really young artists opportunities?" And Jesse said, "You don't need to convince anybody."

Bert Long: Listen. I want to jump in on the bandwagon, because I owe a lot to that man right there.

Jesse Lott: You're my man.

[*laughs*]

Bert Long: I first came down here, and I was craving a little excitement in the art world. I went over to Jesse, and every time I do lectures I tell people about this. One of the most important things I've ever heard, especially being an artist of color, and we will all together have to deal with the system being an artist of color, and Jesse said, "You are out here. You are doing it. You are making the waves. You are going to have to learn a couple of things. You gotta learn the language of art and be able to talk." Then he said, "You shouldn't be so worried about trying to fit into their system. You should create your own system, and they'll come to your system." That's it. I started writing in the newspapers. I wrote an article about the Museum of Fine Arts and an article called "A Fish Pinched from his Head First." And man, let me tell you . . .

[laughs]

[Someone]: What is the paper again?

Bert Long: *Art Scene*, it's all in microfiche. I made sure that it was put on the record for the history down at the library. Well, you know how that came about? That came about because thinking about Louis Randolph first thing. You want to control something on press. Those are the things that Jesse and Artists in Action taught all of us. We haven't talked about you. My brother here, Bert Samples, has been there in the thick of an elitist crowd forever. He's a top curator at the Museum of Fine Arts.

Bert Samples: Top curator?

[laughs]

Bert Long: Well, you were one of the only ones.

Bert Samples: I'm just a brother behind the scenes.

Rick Lowe: You were one of the first in the Core Program [Core Residency Program at the Glassell School of Art], right?

Bert Samples: Yes. Second one.

Bert Long: How many years has it been?

Bert Samples: Like twenty-nine *[laughs]*.

Rick Lowe: Okay. So, going back to that show, so that was the first time.

Bert Samples: That was the first show, before there were Jesse and Bert or Jesse and Floyd for a show. But as for what I recollect, the initiative, the idea came from us. It wasn't that we were selected by somebody else to be in the show. And I credited Floyd because he was the artist in residence at that gallery space. Maybe it was Fletcher [Mackey].

Jesse Lott: It might have been Fletcher.

Bert Samples: Yeah, Fletcher.

[everyone agrees]

Bert Long: Fletcher is at the Maryland Institute now, isn't he?

Bert Samples: Yeah, yeah. That makes sense.

Jesse Lott: That was well before Snug Harbor [an exhibition at Snug Harbor Cultural Center on Staten Island, New York, featuring work by Jesse Lott and Rick Lowe, part of an event called *1992 The Americas?*].

Rick Lowe: That was the fourth show, and see now that is another key point. See I remember Snug Harbor was in '92, but before that I started to get really close to Bert Samples when we started organizing the Union of Independent Artists [UIA].

Bert Samples: I remember you calling and saying, "I want to show you something," one morning. You pull up right by the row houses, and they were all boarded up at that point. Then that's when I know we started having more regular meetings, and that is the transition from the UIA to Row Houses. We started meeting at Michelle Barnes's place, at the collective, and she started bringing in others. . . . We were using some of the resources of the collective and the UIA because the UIA had started a newsletter. We did several events. We did a show that we protested in front of this corporation building on San Felipe.

Rick Lowe: Do you remember the one that had a running tree?

Bert Samples: The one that had the puppets and the running tree.

Rick Lowe: That was one of the best protests I've ever seen. I remember we were protesting the cutting down of the redwoods, and so we made this big papier-mâché tree with somebody in it. And so the tree would go to the lawn, and the tree would run back. It was beautiful man! Every time the police would come the tree came running back. That was a great scene.

[*everyone agrees*]

Bert Long: The last meeting I remember was when we wanted to do the suitcase project.

Jesse Lott: Oh, yeah. That is a good one.

Bert Long: Each one of us would do a print that would fit into a suitcase, and it would go somewhere. You could sell prints out of there. We should still do that show because we haven't done anything collective lately.

DOING WHAT IS NECESSARY AND NEEDS TO BE DONE

Rick Lowe: I knew Bert [Long], kinda from Commerce Street because we were around there with the Union of Independent Artists. I think I knew you guys on the periphery. I didn't really *know* you, but there was a sense at a certain point, that I had, that I was the last one to come to town. I came in, and I jumped right in with the Commerce Street art scene, and you know, it took me about a year to start. But there was this kind of natural yearning, to say, You know, *I'm here*. There are all of these white artists, a community of people. But there was something that was still missing. That is when I started thinking more about

[John] Biggers and that whole African American art side. I had started out in a place where that was not even on the radar at all.

Bert Long: I am sitting here now, and I am saying to myself, I'm really proud of the fact that we did what we kinda . . . Well, we are still doing it. But we were never attacking the white artists. We didn't even talk about them. It was just about us doing what is necessary and needs to be done.

Rick Lowe: Yeah.

Bert Long: There was always a focus of okay, what can we do next? And it wasn't about, we are gonna make some money. It was about, okay, what can we do to try to enhance the situation, as our obligation as artists. That came from him too.

Rick Lowe: Yeah. It was one of those things. When I realized that I really needed that connection was when we were working with UIA. We started to do things connected with issues that were relative to black people. And, then all of a sudden, the UIA started saying, and then all those people started saying, "Wait a minute, we don't want to go to that S.H.A.P.E. Community Center and do anything. That doesn't have anything to do with us." The group started doing all these protests. I mean, we did the redwoods one, we did one down where there was a medical waste facility, the freedom of expression, the Persian Gulf War. They were all over it. Then when we said, "There is this police brutality thing that is happening, you know? We should show our voice." And all of a sudden it was like . . . [*silence*].

[*laughs*]

Bert Samples: I remember talking to the group and saying, "We are in a poisonous community. Artists in Houston have no voice." And we, instead of sitting back like many years and years expecting for this dealer, or that collector to pull us out, we said, "Well, we'll just do it on our own. We don't need no gallery. We'll show in our warehouse spaces, in our studios, we can get the word out." So we are empowering the whole artist community, but then it's like you said, when we wanted to focus on African American communities, like Third Ward, that is when [we realized] what it was. We had this clique over here, this clique over there, and then it wasn't no unity. Because it sounded like an oxymoron: a union of independent artists. You know? It just didn't fit, but it worked for a short time, and people put a lot of time in it.

Rick Lowe: It was five hundred members at one point. It was huge.

Bert Samples: And so I remember when I got my degree, my sister looked at it and she just laughed. She said, "What the hell are you gonna do with this? You might as well work at the post office." So that kind of dark future was always brewing there. Then, when I started connecting with you guys, there was no kind of defeatism in the language, in the presentation. We weren't only representing ourselves, we were representing younger people that were

coming, that hadn't been there yet. When they arrive they have something to move toward, there is already a trail that has been established. That was the best thing about the Row Houses because it was the first time that everyone can find a warehouse and set in their space, and is always in a part of town where there is no activity there, except for the nine to five hours. Then you have all the kids from the suburbs congregate there all weekend, and hang out. But these were the places where we lived and worked, and they would just be there for a few hours and then move on. They had no interaction with anybody or anything. Now, it may have been industrial, but there were people living the next block around there. This is the first time I can see where you have an active organization that is engaged with the community around them.

HOW DID YOU GET THAT JOB?

Floyd Newsum: Bert, how did you get that job at the end of it?

[*laughs*]

Rick Lowe: [*mocking*] How did you get that job?

[*laughs*]

Bert Samples: I don't know if I want to go down that road, but . . .

[*laughs*]

Rick Lowe: He don't wanna give away the secret.

[*laughs*]

Floyd Newsum: I'll tell you how I got mine, kinda like George. When I had come down here in '76, I had already gone and accepted Prairie View A&M and I was hired, but I had this one question.

I asked President Thompson, "President Thompson, now I have been trained at all these different schools, and all these schools taught me a lot of things I want to teach African Americans." He said, "What do you mean?" I said, "Well look, I know that at most African American schools they never teach figure drawing." He said, "What is figure drawing?" I said, "Well it's drawing the nude." He says, "Huh?" [*laughs*] He said, "Well, if the boy's women come around here, they'll get upset." So I went to Philly, and called my dad. I say, "Dad, I got a job down in Texas in this place called Prairie View, and I don't know what it is. It's some country. I didn't even see any big buildings." [*laughs*] "I am scared to go down there because the guy will not let me teach what I would like to teach the brothers and sisters." He said, "Son, you know you gotta wife and a baby coming, and so you might want to reconsider. You might want to take that job." And I said to myself, If I go down there, I am gonna feel really upset, and I won't be able to function. So I declined.

So for a whole year I worked as a postman, taught part-time, and worked at Sears. I sent my resume [to University of Houston], and I got a letter saying they

had transferred my resume from the central campus to the downtown campus. So, I get an interview. I got over there. I got off the airplane, and the chairperson met me. We were driving; he said, "Look now don't be nervous." Then I said, "Mmm-hmm." I ain't nervous. I have been practicing for all these years, visiting all over the country. I said to myself, No problem. I got to the interview, and I actually carried the interview, cause there weren't any art people there, so I had to make conversation about what I needed to do and what I wanted to do. So actually I already knew I had the job. Then when I got there, I thought I was the second of color. And so it was a blessing, cause they needed some of us, I guess, being the second. But you know, my history is that I had to fight. But that is fine with me cause I be struggling.

Bert Long: Well, look at Dr. Biggers. How did we get to Texas Southern [University]? It's always about somebody helping you. I had a great show at the Museum of Fine Arts and everything, but I don't mind saying that there are a lot of elements to that. Sure, my work had to measure up and everything, but it also happened because they thought I was dying. You understand? Those things enter into it. If it hadn't been for James Surls, if I hadn't met this man here [*pointing to Jesse*], a lot of things would be different—my whole philosophy came from you [Jesse] and Salvador Dalí.

Jesse Lott: Two crazy people [*laughs*].

Bert Long: The only [art] class that I had in Fifth Ward was with Mrs. Ladner at Phyllis Wheatley High School. I was told that there was only one other African American artist or black artist at that time. He was at the school, and he was really a great draughtsman. So they told him that he could be an artist at some illustration firm and stuff like that. And basically they told me that there was no possibility for me to be an artist. No possibility. They still tell me this [*laughs*]. No. I am saying because, right now, of all those people that went to Texas Southern and African American universities, real honest, wanting to be artists, how many actually go on to really live it? All of us are living it. Rick does his art in different ways, he is not making objects, but he is still doing his art. He moved over into the "Nude Descending the Stairs," that kind of a thing, you understand, concepts and stuff like that [*laughs*]. But we are still making our art. We are still doing it.

TOWARD A DEFINITION OF "BLACK ART"

Rick Lowe: Yeah, but one thing we haven't brought up in this is James Bettison, the Ball of Energy.

Bert Long: We are missing him.

Rick Lowe: He was really a whirlwind of energy that was kind of moving and hitting everybody that came his way.

Bert Long: I got two pieces of his hanging in my house.

Jesse Lott: He's the individual, you see? He went beyond qualifications and the pigeonholes. You could not pin Big James down in a category. He was black. He didn't do no black art. He didn't do no white art either. He didn't do no conceptual art. Never, never, he accepted no categorization. That is what I liked about him.

Bert Long: You can say that about all of us, though. We are all African American artists, but we are not known for making black art. John Ross, he is one of the greatest modernists ever. You understand? Okay, and Bert Samples. I like his drawings, they're as great as anything. And if someone were to look through the three thousand pieces of work I have made, they could put a show about being black together. They could put a show together of fence posts, because I take thousands of them.

Bert Samples: How do you define black art though?

Bert Long: Well, I didn't go to school! I didn't go to school, so I am using it loosely. I am talking about black genre.

Jesse Lott: Some reference to the black social development, the black sensibilities, and, sometimes, it is actually done by black people.

[*laughs*]

Bert Samples: I didn't think about it that way, but I think change was the catalyst of us really galvanizing in a way. Like you say, you defy all types of categories. And we were all defying those categorizations ourselves, because we were trying to grow out of something that didn't have no future. It didn't have no future, at least in the Houston community. So we were redefining ourselves. But I really think that change was the catalyst for that because you have to accept James on his own terms. You know?

Rick Lowe: And he always had that entry; he wanted to do something. "Let's do something." You know? That was his thing. "Let's do something, let's do it, let's do it." At that time when we were all coming together, I know that for myself being new in town, trying to find my way, and find connections. George, you were kind of over at Rice [University], in that different world. It was obvious that there weren't a lot of black artists in this town. So when we were starting to come together, you had people that you had trained and taught.

Floyd Newsum: Yeah, but they were not getting opportunities.

Rick Lowe: And Bert, you knew people, but they weren't people that were operating in the places that we were. And this is interesting now, I can see a whole other generation that is like another pocket of African American artists, Tierney Malone and those guys that do their thing. It's a completely different dynamic now than it was then.

Jesse Lott: I can tell you that the difference is that right now it is wide open, back then it was closed shut.

Floyd Newsum: It sure was.

Jesse Lott: They only let one or two through the door.

Bert Samples: That was the moment that the museum desegregated their policies. It was that they had an annual competition, and for the announcement of who won first place, *first prize* and he was not able to attend his opening because it was on Friday and—

Jesse Lott: We could only go on Thursday.

Bert Samples: Or Sunday.

Jesse Lott: [*laughs*] Yeah!

Bert Samples: I have a picture of this teacher taking their students through the south gate and going up the stairs looking at one of the sculptures. That happened to him at the MFAH [Museum of Fine Arts, Houston], it happened also in Dallas, but in a worse way, because when he won first prize, and he came to the museum to receive his check, they didn't even let him into the building. They just opened the door and just gave him the check [*laughs*].

So here we have someone who is this great icon, because now he is international, but at the time, those policies were so entrenched that it sharpened the vision of the students at that time. "How can I even compare myself to Dr. Biggers, what would it take?" And the characters that they would beat into you every day you were there was perseverance. I mean, hammering you down. It is what they call running through the fire.

Bert Long: I think it is one of the more important traits, and that is why I brought it up twice now, and he just brought it up. I think it is almost a miracle that we are still here.

Bert Samples: Schools had the same problem in Maryland. That is something that happened to a lot of black artists across the country.

TO BE AN ARTIST PRACTICING IN HOUSTON

Rick Lowe: Let me ask you this. I want to tie into your thing about the fact that Biggers, back then it was a certain way, and now he is known. But still there is a sense in my mind that the stature of John Biggers, the level of his work and his accomplishments, is still not acknowledged at a level that it should be. I'm gonna bring this into a broader conversation about what happens, cause I think that Biggers is a little regionalized, basically. And we are all sitting here as artists. And usually regionalized means that you are not in New York, right? Cause New York is a region too, but they don't consider themselves a region. So we all chose to live here, to make this our home, but all to our own satisfaction do things in different places to fill what we desire. Basically, I guess that is to match whatever our ambition is with our work and how we see it, what role we see it playing. So that is a question though about what it means to be an artist

practicing in Houston, not so much just among ourselves among the generations here, but relative to the greater context.

Bert Long: I'm gonna say that it is not only being African American and working in Houston, it is being still as an African American artist period on the national and international scene. And, listen to hundreds and hundreds of lectures showing stuff and out in the public and different places. I had one of my biggest collectors say, "Bert, why are you complaining? You've made money." And that is nice, but I don't see twenty-million-dollar commissions like Richard Serra, you understand? Mel [Chin] makes a lot of money, but we haven't reached that point. We are not there.

Rick Lowe: Even when you start looking at the younger generation of people, when you start looking at people like Julie Mehretu and Mark Bradford, artists who are the youngest hot artists that are selling work for big dollars. And I caught myself thinking this the other day when I was with Mark. We were at his gallery, and there were pieces that were on the waiting list, and they were two hundred to three hundred thousand. But then there are people on the other side [making more money], and you think *what* other people? I mean [two hundred thousand] it is a lot of money, but it is still not at all comparable.

Bert Long: I want to say this. Houston has been great to me. Houston, and a lot of great things, have happened to me, but I spent my whole lifetime trying to get the hell out of here [*laughs*]. It is true! And it is not arrogance or anything. My goal is to try to realize my potential fully. Truthfully I was telling Floyd today, I wouldn't be back in Houston. I had already made up my mind to stay in Europe and to deal with New York and not to come back. I came back because my wife died and then I got involved. And now it is out of the question to go. But that is the reality of living in Houston. Even if you are so called successful . . . But Houston has been good to me. Houston is still a place where you can make things happen.

Right now the gallery scene here and everything is totally flat. There are only one or two places that are really showing on the international scene. I mean if anybody is showing. Nathaniel [Donnett], he is talking about a bigger picture. We have talked about it too before. The bigger picture, but really the bigger picture, you persevere and really you hammer and you hammer and you hammer, and what Jesse said about a show, recognition. You know? Like Jewish groups: don't let them forget. That is why I am glad to be here. Don't let them forget; this still happened. We are here now; it is on the record. It is important. We have an obligation and a role to play to be a mirror of what has happened, and it will pay off, and they will have a map. You understand? I didn't have a map. I read every book I could. That is where it came from.

George Smith: I started at North Carolina A&T. And I left there because there was a woman there, a practician there, and she said, "If you really want to be an artist, you are too good to be here." She said, "You need to go to New York." [*laughs*] No, seriously. And I tell you I had a book, and then she bought me a book, and it was a book on John Biggers. But I had only ever known of a few other black people, like Richard Hunt.

Bert Long: Richard Hunt was my connection.

George Smith: Yeah, mine too. I didn't know anything about black artists, so he brought me this book, and it was about John Biggers. That is why I mention it, the book.

Bert Long: I have it, and I am glad you brought up Richard Hunt.

George Smith: It was inspiring to see.

Bert Long: Richard Hunt was the first. He was the first artist I met in New York, and I took time and visited him in the studio. That was my first connection with the international art world there. God, he's . . . I think of you when I look at his drawings. You understand? I mean you guys are great draftsmen on paper and stuff.

Bert Samples: Well, you know, I've visited him. I've searched him out. We went out to dinner. He took me to an opera. He is really into opera and stuff like that.

Bert Long: Absolutely. He is still ahead of his time.

Bert Samples: Yeah, he is.

WHEN RICK WAS A BOY

Thelma Smith [George Smith's wife]: Can I tell my Rick story?

Rick Lowe: Oh lord! I don't wanna be here.

Thelma Smith: It is just a little story. It makes me feel good when I think about it. When Rick was a boy.

Bert Long: You mean he had hair?

Thelma Smith: With the hair, yeah. I think he had a studio in the Heights or something like that. He would come to visit the Rothko Chapel where I was working. Do you remember those days? Oh, my goodness.

Rick Lowe: Oh, yes. Those were drinking days.

Thelma Smith: The person working in the chapel, her name was Lucia, and I don't know if Rick knew this but he was not the perfect person. He had a lot of nerve for her, being the color that he was, with this hair, and coming into the chapel all the time, all loud and just like paying no attention to her. She was . . . well, I don't want to sound prejudice, but I guess I can. She didn't have children, she didn't like children, but she certainly didn't like certain children. [*laughs*]

Rick would come in there. She had this white hair that was real stiff. You remember her?

Rick Lowe: I remember her.

Thelma Smith: He would come in there with his friends talking. And, what I'll never forget, this is the part that I really always want to remember about Rick, is that Rick was then, and is today, the same person. I remember that at the Rothko Chapel they have a lot of discussions; I don't remember what the exact topic was, but they were filming and everything. And so Rick went outside, and he was sitting on the bench, and this Caucasian man, he came outside also, and he was talking and talking. In a sense, he was about to say that certain people deserve to be on a higher level than others. Needless to say, Rick was not having that. So they got in a discussion, an argument. I remember Rick saying something like, "So you think that that man working at the plant is not as good as this other man."

Rick Lowe: I kinda remember that too.

Thelma Smith: And I was pretty impressed. I said, "Alright!" Because I appreciate the fact that he would confront this person like that.

Rick Lowe: Well, you know probably to my fault. I haven't figured out to say things . . .

Bert Long: Diplomatically.

Rick Lowe: Diplomatically. That lady you are talking about at the Rothko was one of my first connections with Dominique de Menil because of the habit that Nestor, my old running mate that I had at the time, we would come in there on Sundays kind of hungover.

Thelma Smith: Oh, God.

[*laughs*]

Rick Lowe: It was a peaceful place to recuperate. So we would go in there, and at that time they didn't have those glass doors and all that stuff. It was much more open, and people would be doing tai chi, whatever. And we would go in there and lay down on those benches, and that lady came, that's why I remember that she didn't like me because she came up and said, "You are not supposed to lay down on the benches." And Dominique came in there at that time and told her, "Leave them alone."

Thelma Smith: Yes.

Rick Lowe: "Leave them alone. What's wrong with what they are doing?" And that is when she really hated me.

Thelma Smith: But Mrs. de Menil had done the same thing to me. She was coming in. See, I was a little bit in fear with people, and this couple was on the bench with their heads pointed towards and their feet on the end pointed like this. And Mrs. de Menil was coming, and I thought, I'm gonna have to get these

people up. So I went in to tell them to get up, and Mrs. de Menil got back to the door, and she saw what I was doing. She pointed her finger at me and did like this [*gestures*].

[*laughs*]

Bert Long: Mrs. de Menil, the great thing about her in the art history, being a black artist in Houston, she would always invite me, especially when I was doing the paper, to her private dinners. I haven't been invited to one since she died [*laughs*]. When I did my first monumental ice piece at the 12th International Sculpture Conference in San Francisco, Mrs. de Menil wrote the first check: two hundred dollars. It is somewhere in my archive. She wrote the first check. She was always there. The De Luxe Show in the 1970s, that was Mrs. Dominique de Menil.

FIFTH WARD AND THE DE LUXE SHOW

Rick Lowe: Now, were you around when the De Luxe Show happened?

Bert Long: The De Luxe Show with Mrs. de Menil and all the guys. I wasn't a part of it. I wasn't in the art world at the time. I was a chef.

Jesse Lott: It was way back in the early '70s. They brought a lot of artists in from New York. I helped set it up, but this is the funny part. You want me to tell it?

Bert Long: You gotta tell it.

Jesse Lott: Dr. Biggers was one, the spearhead artist. And Carroll Simms. He was one of the brothers that was setting this thing up and Harry Vital. So they were selecting artists, and at first they were selecting local artists, but as the notoriety about the upcoming show got to be greater and greater, it started to change, and people out, and putting in big timers, New York artists, really.

Rick Lowe: Were Biggers and Simms even in the show?

Jesse Lott: No, they were running it. They were the ones that did the setup and the presentation, and as a matter of fact I was the last local artist to get excluded! You know, the exhibition was supposed to be about black art in Fifth Ward, and where my studio is right now is only about six blocks away from it, right down the street from it. One of our state representatives, he did his campaign speech directly across the street from where my studio is. I'll never forget it—he said, "I am coming to you from the worst part of the worst neighborhood in the United States of America."

WE GOT A NEW YORK ARTIST HERE

Bert Long: You are talking about those New York artists; we got a New York artist here [*pointing to George Smith*].

[*laughs*]

Rick Lowe: He was brought in to civilize you. George, so you came here straight to teach at Rice?

George Smith: Yeah. They wouldn't say it, but they recruited me. The reason why I said okay is because Jim Harithas was down here, and I kinda talked with him a little bit. He said, "Yeah, it's cool."

Rick Lowe: Did you know him from before?

George Smith: Yeah, he gave me my first one-man show in New York. He gave me a show at the Everson [Museum in Syracuse], and from there he went to another museum and gave me a show there, so things were happening from Jim, and we became good friends. He was a professor at Hunter College when I met him, and what was good about Jim is that Jim was trying to integrate, well, it was integrated anyway, but he was trying to put blacks in his class.

Bert Samples: Tell us the story about the class and about how you were perceived.

George Smith: How I was perceived? What do you mean by that?

Jesse Lott: He's talking about the canvas rip up.

George Smith: I did a piece where I ripped a canvas up, a big roll of canvas, and it was really a music piece [*laughs*] because I rolled the paper on jazz, and then I took a Hula-Hoop, or not a Hula-Hoop, a fire hose, or what do you call that—the pipe that they use to clean the water. The corrugated pipe used in swimming pools. You can roll it up and make sound with it, but I had a big one and it made a sound. We were on the roof at Hunter College; we were like fifteen floors up. Some of the administration came out to see what was going on.

Bert Long: So when they saw you ripping up that, they said, "Uh-oh, maybe we made a mistake."

[*laughs*]

George Smith: No, but you know the funny thing about that is that a lot of people in the class, in particular white artists, cause most of them were, there were three black artists, they would know a lot about conceptual stuff, so it wasn't anything different. It's just that when I did it, I was perceived as angry, but I was just doing conceptual stuff.

TO ESTABLISH NEW YORK IN HOUSTON

Rick Lowe: That was around the time I was thinking about Houston, when I was in school, and I looked in magazines and she [Linda Cathcart] popped up a lot, in association with Houston.

Jesse Lott: Yeah, she kinda liked to establish New York in Houston.

Floyd Newsum: They used to have these art galleries at Rice in Sewall Hall in the back of this auditorium, and she had invited the director that founded the New Museum in New York, Marcia Tucker. And Marcia is going to be showing what is new; you know, who are the upcoming artists that she has been looking at in the New York area. So the rumors went that there was a lot of dealers and the art community there, and then Linda Cathcart [director of the Contemporary Arts Museum, Houston, during the 1980s] was invited to show who she's been looking at, and she was going to show New York artists as well, so no one in Houston [was represented]. The only person that she showed, the only African American artist, was [Robert] Colescott. She showed the painting that he did [reworking *The Potato Eaters* by Vincent van Gogh] called *Eat dem Taters*. Me and George just looked at each other, and I just remember that look that I had, and I remember the look that he had, like, We are going to be the first ones out of here.

[*laughs*]

Rick Lowe: You didn't wait to be asked?

Floyd Newsum: We didn't wait. It was interesting what Jesse talked about cause my perception of the De Luxe Show was different; I didn't realize that Dr. Biggers and Carroll Simms were involved in the conceptualizing of it. All I remember was an artist, I think his name was Peter, but he was the son of Miles Davis. [The De Luxe Show was an historic art exhibition organized by the Menil Foundation. One of the first racially integrated exhibitions of contemporary art in the United States, the show was held in the De Luxe movie theater in the heart of Houston's Fifth Ward.]

George Smith: Peter Bradley.

[*everyone agrees*]

Floyd Newsum: They brought him in to organize and curate the show.

Rick Lowe: That is probably how, like a lot of things happen, they start out locally and then it's like now we have to bring somebody in from the big city to help them out.

MY BRIAR PATCH

Rick Lowe: I want to say something about the out-of-town/in-town thing. It has always been interesting for me being in this kind of group. Cause I always knew from meeting Bert that he wanted out of here, I mean when he was in Spain. And then, I also at the same time got to know Jesse, who is somebody who really didn't want to leave Fifth [*laughs*]. You know, and so it was always this kind of nice balance for me to understand that thing of how it works that way. Some people just have a need to do this, some don't, and Jesse, I kind of have a sense of

why you are comfortable. Can you talk a little bit about it?

Jesse Lott: You know a thing about Uncle Remus?

Rick Lowe: A little bit.

Jesse Lott: You ever read the story about the rabbit, the fox, and the tar baby?

Rick Lowe: Tell it.

Jesse Lott: Well, Fifth Ward is my briar patch. I am comfortable right there. I can run through the briars and run through the bushes. Never have to worry. You know what I'm saying? I am at home. And it is all about what it takes to give you that validation that every human being needs. Some people think of money, but how many millions of dollars do you have to have? Bill Gates is still working. Why? Everybody needs something else. As artists, what do we have to offer? You are only as powerful as your sphere of influence. If you are doing what you can where you are, that is the best you can do. Or, you can go somewhere else and do something else that you can't do.

[*laughs*]

WE ARE NOT AN ISLAND UNTO OURSELVES

Rick Lowe: I want to go back and say one thing. There was something I said earlier that I wanna clean up a little bit, or at least put it in context. And I am saying this to honor Jesse in his teaching way, the way that Bert has done here. I was talking about the issue with the Union of Independent Artists—being a leader in that group, starting to do things in the African American community, and not having support of the broader group. I had [previously] been developing this attitude: I am going to TSU [Texas Southern University]. I am discovering my black side. I am going to involve myself and surround myself in a place where I belong. But at that point, I was about to just move away. It was through coming together in this group—and Jesse has always had this comfort level about where he lived, where he worked, what his work was all about—that whole thing opened me up. *That* actually allowed Project Row Houses to happen. I actually sat around and talked about these ideas. When we started working over [at Project Row Houses], it was all kind of people, from all over. So that same thing that felt defeating at one point, when people wouldn't come to support something that was happening around the black cause, later proved itself to be the opposite. That was kind of an interesting twist.

Bert Samples: I think that we all individually, prior to that, had made some types of investments into our future and their future. Because we are all very engaged in that, working around different parts of the city doing things. So we had, even at the early stage, created kind of a trust organism, stability. If those guys come together, if they are that committed to doing something, I know if they have done it in the past, maybe we need to get behind this. And, it probably wasn't just a collective awareness, but I think that it came to that point at some

point, but just a continuation of meeting. You know, for artists to meet as a group. That is just a unique phenomena particularly back then, because you are still around these old kind of paradox, "Okay, I just need to be working in my studio; someone is gonna find the greatness in me."

Rick Lowe: Well, and that is also connected to Jesse's theory always too, but I remember that it was almost like, they had to come to help us. Because if we did it by ourselves, it would have given us too much power. You want people to come around and to be involved and just do it. If you are doing it, then the rest of the world is not gonna let you do it by yourself because that is too empowering.

Bert Long: It reminds me of Chris Rock telling a joke: "We don't have any black leaders, but we do have Al Sharpton and Jesse Jackson. Look at Jesse Jackson, he went over there and got all those hostages." Then Chris Rock said, "When he got 'em, he told the people that were holding them, 'Do you really want to make the USA mad? Let *me* have them.'" [*laughs*]

You have to know that there is a glass ceiling. So it is the same concept that we still face as artists right now. You know, my son says to me, as one of the young people these days that has an education, making the money, and everything . . . he wants to say, "Well, *you* went through bad times." And I say, "You still have to understand that things are not perfect."

Putting together this conversation—I am glad we did this. We need to have this. We are talking about things like Mrs. de Menil and artists that are not here, but really it's at the core of where we are. Because we are not an island to ourselves.

Floyd Newsum: Mmm-hmm.

Bert Samples: Exactly.

Jesse Lott: Amen, brother.

This interview was originally published as "Doing What Is Necessary and Needs To Be Done: A Roundtable" in *book club book*, 2011, a publication of Future Plan and Program, which was incubated by PRH, in 2010–11, with artist Steffani Jemison during her residency at PRH. Jemison's residency was part of a collaboration with the Core Program at the Glassell School of Art of the Museum of Fine Arts, Houston. Future Plan and Program was generously funded, in part, by the following individuals: Kerry Inman and Denby Auble, John Roberson and John Blackmon, Danielle Antoinette Burns, Justin Cavin, Jereann Chaney, Melody Clark, Ashley Clemmer Hoffman and Brendan Hoffman, Phyllis L. McCallum and Steven Jemison, Joey Romano and Nicole Laurent, Victoria Thomas McGhee, Scott Sawyer and Michael Peranteau, Gregory and Diane Schultz, Leigh and Reggie Smith, and Rebecca Trahan. Special thanks to Jill Whitten and Robert Proctor, as well as thanks to Aisen Chacin, Cheryl Flores, Solkem N'Gangbet, Nikki Pressley, Linda Shearer, and Michael Kahlil Taylor.

Artist Rounds and Participants

Project Row Houses holds Rounds of artists' installations in its shotgun-style row houses in Spring and Fall of every year. Below is a list of artists who have participated in the Rounds since the founding of the organization in 1993. As part of the PRH Public Art Program, we work with artists to push the boundaries of the traditional definition of "art" and "artist" by encouraging artists to extend their practice outside of traditional spaces and into more complex landscapes. For PRH Rounds, artists create responsive and site-specific installations. The Rounds below have been organized and curated by PRH staff including Reginald Adams, Jennie King, Rick Lowe, Fletcher Mackey, as well as Robert Pruitt (2004–08), Ashley Hoffman (2006–12), and Ryan N. Dennis (2012–present), unless otherwise noted. We are most grateful to the organizers, curators, artists, advocates, longtime supporters, partners, and everyone else who has made the Rounds powerful showcases for platforming creative expression and ideas that are accessible to the Third Ward community.

ROUND 1
October 1994
Steve Jones
Annette Lawrence
Jesse Lott
Tierney Malone
Vicki Meek
Floyd Newsum and David McGee
Colette Veasey-Cullors

ROUND 2
April 1995
Radcliffe Bailey
Carter Ernst and Paul Kittelson
Leamon Green
Earlie Hudnall Jr.
Fletcher Mackey
Anastasia Sams
George Smith

ROUND 3
October 1995
Anitra Blayton
Henry Ray Clark
Ben DeSoto
Jean Lacy
Whitfield Lovell
Bob Powell
Sheila Pree

ROUND 4
April 1996
James Bettison
Marsha Dorsey-Outlaw
Tracy Hicks
Shahzia Sikander
Fred Wilson

ROUND 5
October 1996
Guest curated by Tierney Malone
Barsamian
Sharon Englestein
Tierney Malone
Ron Smith and Sebastian Whitaker
Greg Tate
Angela Williamson

ROUND 6
April 1997
Michelle Engleman
Dan Havel
Natalie Lovejoy
Motopa
Bert Samples
Kaneem Smith
Strickly Roots (Jameelah)

ROUND 7

October 1997

Dottie Allen
John Baran
Stanford Carpenter
Naomi Carrier
Colette Gaiter
Celia Munoz
Gary Reece
Josefa Vaughan

ROUND 8

April 1998

Guest curated by Alvia Wardlaw

Joseph Dixon and Linda Gibbs
Ronald Gray
Greg Henry
Ann Johnson
Bert Long Jr.
Thom Shaw
Cleveland Turner

ROUND 9

October 1998

Edgar Arceneaux
Michelle Barnes and Troy Gooden
Mark Greenfield
Seitu Jones
John Outterbridge
Jan Roddy and Georgia Wessel
Space One Eleven
Tricia Ward

ROUND 10

April 1999

Jason Asbahr
Kweku and Barbara Bediko
Vandorn Hinnant
Lawrence Hitz
Julie Mehretu and Amy Brock
Kay Nguyen
Rhonda Radford and Reginald Adams
Elena Cusi Wortham

ROUND 11

October 1999

Guest curated by Jerome Sans

Jens Haaning
Joseph Havel
Annette Lawrence
Jerome Sans
Christopher Sperandio and
 Simon Grennan
Rirkrit Tiravanija
Nari Ward
Chen Zhen

ROUND 12

April 2000

Melvin Edwards
Homer Jackson and Lloyd Lawrence
Lauren Kelley
Bora Kim
Mark Nelson
Dean Ruck
Nestor Topchy

ROUND 13

October 2000

Amita Bhatt
H. E. Blackwell
Harvey J. Bott
Alesha Chellam
Chevron Team
Donell Long
Projects, Inc.

ROUND 14

April 2001

Guest curated by Bernard Brunon

Bernard Brunon
Paula Hayes
Richard Humann
Jane Jenny
Paula Miller
Melissa Noble
Lucy Orta
Lisa Schoyer

ROUND 15

October 2001

Guest curated by David P. Brown and
* William D. Williams*

Craig Evan Barton

David P. Brown and William D. Williams

J. Yolande Daniels

Felicia Davis

Walter Hood

Shawn Rickenbacker

Sheryl Tucker de Vazquez

ROUND 16

March 2002

"Bert" Bertonaschi

Paul Davis

James Fraher and Roger Wood

Tracy Hicks

Kathy Lovas

Otobong Nkanga

Karen Oliver

Manuel Pellicer and Wes Sandel

ROUND 17

October 2002

Leticia Guillory

Mary Hawkins

Robin Hill

Michael Meazell

Angelbert Metoyer

Dune Patten

Virginia Prescott

ROUND 18

April 2003

Bennie Flores Ansell

Quashelle Curtis

Ibsen Espada

Laurie Jackson

Darryl Lauster

Robert Pruitt

Dolan Smith

ROUND 19

October 2003

Sam Durant

Ada Edwards

Lonnie Graham

Abby Levine

Chuma Okoli

William Steen

Toby Topek

Voices Breaking Boundaries Participating
 Artists (Community Gallery)

Lisa Bjorne

Fernando Brave and Pablo Gimenez
 Zapiola

Shaista Parveen

Sehba Sarwar

Diana Wolfe

ROUND 20

April 2004

Karen Atkinson, Nancy Ganucheau,
 and Jane Jenny

Brian Wesley Heiss

Jesse Lott and Joe Cardella

Fletcher Mackey

Dominique Moody

Shyriaka Morris

ROUND 21

November 2004

Karen Atkinson

Paul Druecke

Carter Ernst

J. Hill

Jane Jenny

Demetrius Oliver

Saba Oskoui

ROUND 22

April 2005

Rotem Balva

Hana Hillerova

Elena Lopez-Poirot

Ike Okafur-Newsum

Peter Simensky

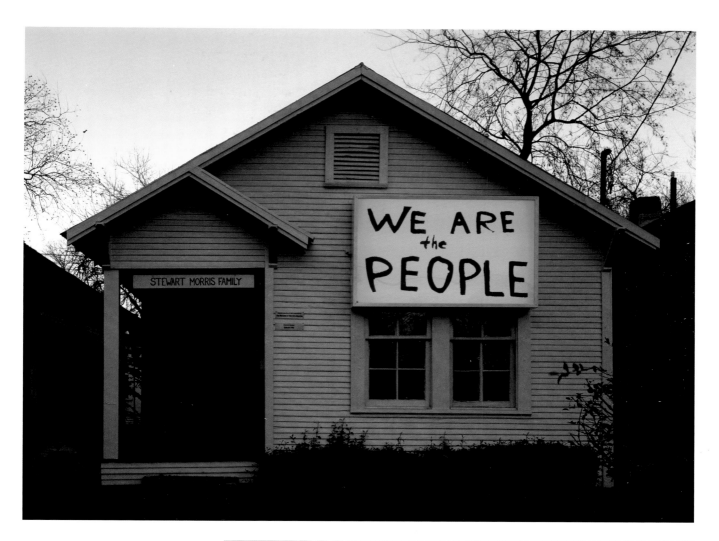

top: Sam Durant, *We Are the People*, 2003.
Round 19

right: Sherman Fleming, *Carrier*, 2008
Round 29

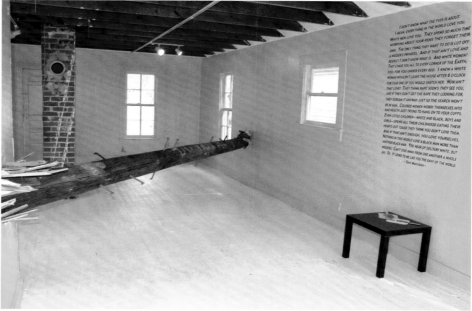

ROUND 23

October 2005

william cordova
Jo Ann Fleischhauer
Michael Golden
Leslie Hewitt
Jimmy Kuehnle
Kaneem Smith

ROUND 24

March 2006

William Aponte, Tyrone Bowie Jr.,
 Jaime Iglesias, Joel Nieves, and
 Daniel Ross
Jeffery Cook
Peggy Diggs
Donald Gensler and Paz Gutierrez
Hector Dio Mendoza
Rich Richardson
Visible Collective (Naeem Mohaiemen)

ROUND 25

October 2006

Conceived by Ingrid Pollard
Faisal Abdul Allah
Rashida Bumbray
Godfried Donkor
Dominique Le Gendre
Charles Huntley Nelson
Dorothea Smartt
Cristal Chanelle Truscott

ROUND 26

March 2007

Pavel Banka
Barsamian
Thurman Brown
Ray Carrington III
Rita Duffy
J. Hill
Aaron Lundy-Bey (Community Gallery)
Lynne McCabe

ROUND 27

October 2007

Chuy Benitez

Nancy Bless
Brendan Fernandes
Letitia Huckabee (Community Gallery)
Lauren Kelley
Susan Plum
Hanalei Ramos
Jeny Ung
Lauren Woods

ROUND 28

March 2008

Rabéa Ballin
Nathaniel Donnett
Robert Hodge
Aliss Macnemara (Who We Are) in
 conjunction with Surviving Hurricane
 Katrina and Rita in Houston
Lovie Olivia
Jullie Spielman
Michael Kahlil Taylor
Jeff Williams

ROUND 29

October 2008

***Thunderbolt Special: The Great Electric
 Show and Dance***
Conceived by Terry Adkins
Terry Adkins
James Andrew Brown
Sherman Fleming
Charles Gaines
El Franco Lee II (Community Gallery)
George Smith

ROUND 30

March 2009

Yinka Adeyemi (Community Gallery)
Gregory Michael Carter
Stephanie Diamond
Rashida Ferdinand
Lance Flowers
Cynthia Giachetti
Lisa Qualls
Stacy-Lynn Waddell

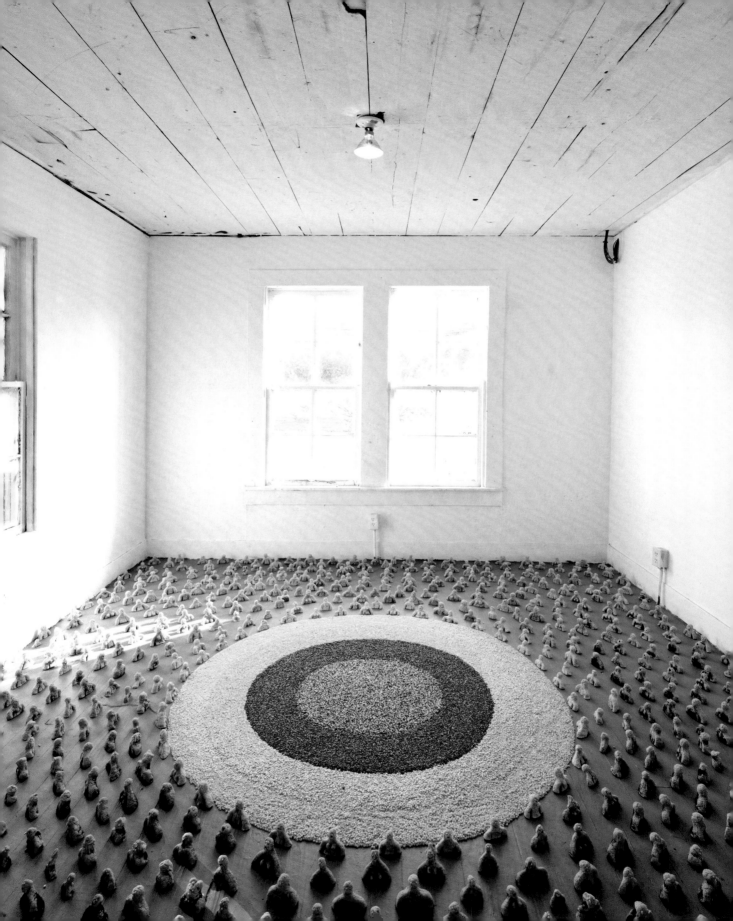

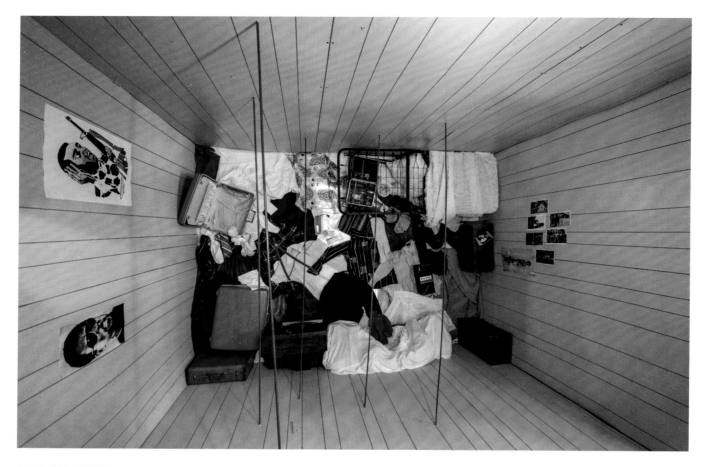

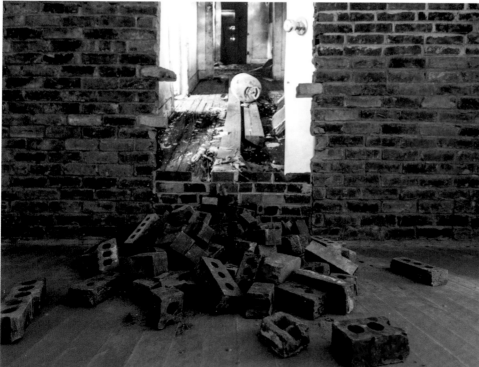

top: Otabenga Jones & Associates, *Monuments*, 2014. Round 40

left: Nathaniel Donnett, *the off-center of invisibility*, 2015. Round 42

ROUND 31

October 2009
Elia Arce
Barsamian
Dave Herman
Jesse Lott
Freddie McCoo
Vicki Meek
Patrick Washington

ROUND 32

March 2010
Guest curated by william cordova
Crystal Campbell
Albert Chong
Coco Fusco
Marina Gutierrez
Ayana Jackson
Minette Mangahas
Glexis Novoa
Mendi and Keith Obadike

ROUND 33

October 9, 2010–February 27, 2011
*Guest curated by Edgar Arceneaux and
 Nery Gabriel Lemus*
Edgar Arceneaux
Andrea Bowers
Charles Gaines
Olga Koumandourous
Nery Gabriel Lemus
Rodney McMillian

ROUND 34

March 26, 2011–June 19, 2011
A Matter of Food
Tarsha M. Gary
Michael Pribich
Jorge Rojas
RootDown H-Town
Luanne Stovall
Tattfoo Tan
Toni Tipton-Martin

ROUND 35

October 15, 2011–March 4, 2012
Regina Agu
Communograph House (Ashley Hunt
 in collaboration with Regina Agu,
 Journey Allen, Lisa E. Harris, Rebecca
 Novak, Ifeanyi "Res" Okoro, and
 Michael Kahlil Taylor)
Sharon Kopriva
Patrick McFarlin
Robert McKnight
Carrie Schneider
Charles Washington

ROUND 36

March 31, 2012–June 24, 2012
Manuel Acevedo
Monica Henderson
Kenyatta Hinkle
Marc Newsome
John Pluecker
Phillip Pyle II
Beth Secor
Irvin Tepper

ROUND 37

October 20, 2012–March 3, 2013
Miguel Amat
Jason Griffiths
In-Situ (Paul Hartley, Kerry Morrison,
 and William Titley)
Autumn Knight
Question Bridge (Chris Johnson,
 Kamal Sinclair, Bayeté Ross Smith,
 and Hank Willis Thomas)
Maurice Roberts

ROUND 38

March 30, 2013–June 23, 2013
Thomas Sayers Ellis
Interchange Participating Artists
 (Interchange is a collaboration between
 Project Row Houses and Space One
 Eleven in Birmingham, Alabama)
 Derek Cracco
 Kenya Evans and M'kina Tapscott

Darin Forehand
Jurgen Tarrasch
Rahul Mitra
Sean Shim-Boyle

ROUND 39
October 5, 2013–March 2, 2014
Looking Back, Moving Forward
Michelle Barnes
Jamal Cyrus in collaboration
 with Ray Carrington III
Troy Gooden
Gabriel Martinez
Lovie Olivia
Valerie Piraino
Anthony Suber
Jessica Vaughn

ROUND 40
March 29, 2014–June 22, 2014
Monuments: Right Beyond the Site
Otabenga Jones & Associates

ROUND 41
October 18, 2014–March 1, 2015
*Process + Action: An Exploration
 of Ideas*
Jessie Anderson
Rabéa Ballin
Julia Brown
Vanessa Diaz
Akua Holt
Rosine Kouamen
Monica Villarreal

ROUND 42
March 28, 2015–June 21, 2015
*The One and the Many: A Self-portrait
 in Seven Parts*
Guest curated by Sally Frater
Alexandre Arrechea
Erika DeFreitas
Delio Delgado
Nathaniel Donnett
Kenya Evans

Ayanna Jolivet Mccloud
Nicole Miller

ROUND 43
October 24, 2015–February 28, 2016
*Small Business/Big Change: Economic
 Perspectives from Artists and
 Artrepreneurs*
Nsenga Knight
Fredia Mitchell
Shani Peters
Kameelah Janan Rasheed
Ella Russell in collaboration with
 Anthony Suber
Martine Syms in collaboration with
 Diamond Stingily
Charisse Weston

ROUND 44
March 26, 2016–June 19, 2016
*Shattering the Concrete: Artists,
 Activists, and Instigators*
Guest curated by Raquel de Anda
The Argus Project (Gan Golan, Ligaiya
 Romero, and Julien Terrell)
Charge (Jennie Ash and Carrie
 Schneider)
Nuria Montiel and John Pluecker
The Natural History Museum (a project
 of Not An Alternative) in collaboration
 with T.E.J.A.S. (Texas Environmental
 Justice Advocacy Services)
People's Paper Co-op (Courtney Bowles
 and Mark Strandquist)
Storyline Media (Rachel Falcone and
 Michael Premo)
Verbobala (Adam Cooper-Terán and
 Logan Phillips)

ROUND 45
October 22, 2016–February 12, 2017
Local Impact
Regina Agu
JooYoung Choi
Sally Glass
Jesse Lott and Ann Harithas

Tierney Malone
Harold Mendez
Patrick Renner

ROUND 46
March 25, 2107–June 4, 2017
***Black Women Artists for Black Lives
 Matter at Project Row Houses***
Co-curated with Simone Leigh
Collective of black women artists active
 in New York, Los Angeles, Chicago,
 London, and Houston

ROUND 47
October 14, 2017–March 25, 2018
***The Act of Doing: Preserving,
 Revitalizing, and Protecting
 Third Ward***
Brian Ellison
Danielle Fanfair, Harrison Guy,
 Marlon Hall, and Anthony Suber
Nikita Hodge
Adelle Main
Sofia Mekonnen
Marc Newsome
Right to Stay, Right to Say (Zeinab
 Bakhiet, Olutomi Subulade, and
 Melanie "Meleekah" Villegas)

FOTOFEST AT PROJECT
ROW HOUSES

FotoFest participants listed below
showed their work at Project Row
Houses in the art houses, with support
from FotoFest. Based in Houston,
FotoFest, a platform for art and ideas,
presents the first and longest-running
international biennial of photography
and new media art in the United States.

March 1996
Albert Chong
Selven O'Keef Jarmon
Karen Sanders
Pat Ward Williams
Fred Wilson

March 1998
Eustáquio Neves
Danny Tisdale

March 2000
Deborah Willis

March 2002
Paul Davis
Otobong Nkanga

March 2004
Rolf Bjorne
Jamal Cyrus
Paul and Eric Hester
Howard Hilliard
Manuel Pellicer
Ingrid Pollard

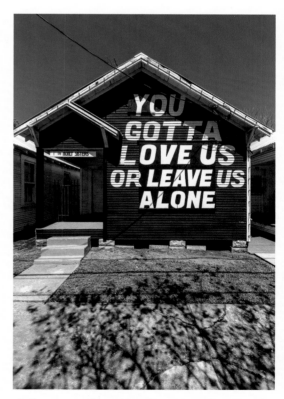

Black Women Artists for Black Lives Matter, *You Gotta
Love Us or Leave Us Alone*, 2017. Round 46

Young Mothers Residential Program Participants 1996–2018

Strong, positive, and long-term relationships matter. In the twenty-two years of the Young Mothers Residential Program, Project Row Houses is hopeful that the experience of the program has afforded these families and individuals with lifelong strong and positive relationships, with opportunities to be part of a community that is invested in them and their future, with experiences that show that we are all valuable, and with time to build supportive networks. PRH continues to learn and understand the fullness of creativity, as well as the various ways for people to see themselves differently and become better versions of themselves. We are grateful to the coordinators, early advocates, mentors, longtime hands-on supporters, past and current team members, and any unknown contributors to the program. We appreciate those who took time to ensure that this list, as accurately as possible, reflects those touched directly by this work.

We know that human error is possible and ask for gentleness for any incorrect representation and/or missing names below.

Jacquelyn Allen
Journey Allen
Keyla Arzu
Nikala Asante
Yhane Bain
Juvette Basile
Myesha Bell
Kiisha Bolden
Kamaria Brooks
Shantricia Brooks
Juanita Brown
Michelle Brown
Rogerlyn Brown
Shariaka Brown
Marisha Bygrave
Keleisha Calloway
Peregrine Chapman
Yvette Chapman
Juanita Olivares Collins
Ethel Curtis
Emerald Daniels
Crystal Davis
Shervonne Edwards
Joidan Felix
Chemeka Fontenot
Celeste Garza

Brittany George
Breonna Goode
Amber Gulley
Jatera Gustave
Tansy Hamm
Akina Helaire
Chelsea Henderson
Marisha Hewett
Jennifer Hilley
Andoneisha Hogan-Campbell
Courtney Horace
Fre'Nedra Houston
Randryia Houston
Camille Howard
Veralisa Hunter
Calyaca Isedore
Desiree Johnson
Shemyra Jones
Monique Jordan
Calina Moon Kumula
Yashica Leaks
Katrina Lovings
Danielle Mason
Jazminn McCloud
Tamara Miller-Hamilton
Terena Molo

Shyriaka Morris
LaTia Newman
Ishokee Overton
Gail Penrice
Sylvia Pompilus
Shannette Prince
Antoinette Ransome
Rese Renay
Assata-Nicole Richards
Andrea Salazar
MyKisha Sams
Nickesha Sanders
Jaquel Smith

Keethora Smith
Kimberly Smith
Miracle Smith
Jessica Taylor
Claudette Vital
J'Quay Wagner
Tiesha Ward
Dominique Washington
Aneesha Williams
Candice Wilson
Scharese Wright
Kira Wycoff

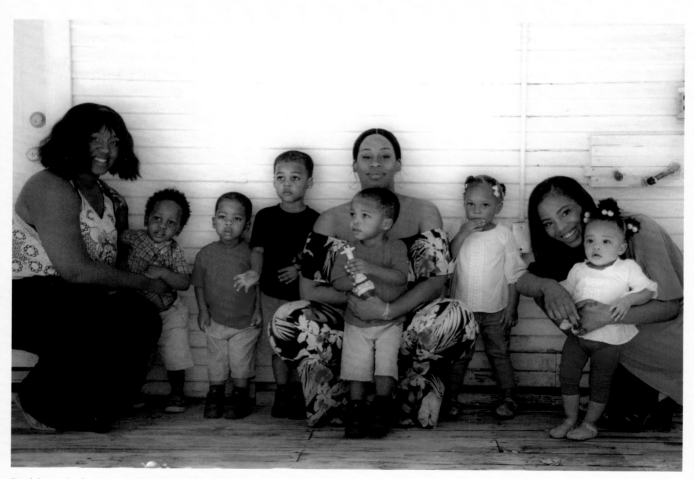

Participants in the Young Mothers Residential Program, 2017

Contributors

Ryan N. Dennis is Curator and Programs Director at Project Row Houses. Her work focuses on African American contemporary art with a particular emphasis on socially engaged practices, site-specific projects, and public interventions. Since joining Project Row Houses in 2012, she has organized and co-organized twelve Rounds of PRH group exhibitions with local, national, and international artists. Her writings have appeared in catalogues and journals, including *Prospect.3 Notes for Now* (2014), *Gulf Coast: A Journal of Literature and Fine Arts*, and the Studio Museum in Harlem's *Studio* magazine. She recently contributed to the first monograph of artist Autumn Knight, *In Rehearsal: Autumn Knight*, published by the Krannert Art Museum. Dennis has been a visiting lecturer and critic at a number of art schools and art institutions throughout the country, and has taught courses on community-based practices and contemporary art at the University of Houston.

Nonya Grenader, FAIA, and **Danny Samuels**, FAIA, have taught design studios and seminars at Rice University since 1994 and 1977 respectively, where they are Professors in the Practice of Architecture. They founded the Rice Building Workshop (RBW) in 1996. RBW design-and-build projects have been featured in numerous publications and exhibitions. Teaching awards include the NCARB Prize for the Integration of Practice and Education, the Collaborative Practice Award from the Association of Collegiate Schools of Architecture (ACSA), and the ACSA/AIA Housing Design Education Award. In 2010, they received the City of Houston Mayor's Citation for Service to Project Row Houses and Houston's Third Ward. Grenader is principal of her own firm, which has a focus on residential and adaptive re-use projects. She is the recipient of AIA Houston's Lifetime Achievement Award (2017). Samuels is a founding partner of Taft Architects, and has worked continually for the firm since 1972.

Sandra Jackson-Dumont is the Frederick P. and Sandra P. Rose Chairman of Education at the Metropolitan Museum of Art where she is responsible for the vision and management of education, public programs, the live arts/performance, audience development, and academic programs. She is known for her ability to blur the lines between academia, popular culture, and nontraditional art-going communities. Jackson-Dumont has organized numerous exhibitions, lectures, performances, symposia, and education initiatives, and she has contributed essays to various publications. Jackson-Dumont currently serves on the boards of the New York City Department of Cultural Affairs Advisory Commission and the Friends of the High Line.

George Lipsitz is Professor of Black Studies and Sociology at the University of California, Santa Barbara. His publications include *How Racism Takes Place* (2011), *The Possessive Investment in Whiteness* (2006), and *A Life in the Struggle* (1995). He won the American Studies Association Angela Y. Davis Prize for Public Scholarship in 2013 and the Bode-Pearson Prize for Career Distinction in 2016. Lipsitz is chair of the board of directors of the African American Policy Forum and chair of the board of directors of the Woodstock Institute. He serves as senior editor of the comparative and relational ethnic studies journal *Kafou*, as editor of the Insubordinate Spaces book series at Temple University Press, and as co-editor of the American Crossroads series at the University of California Press.

Michael McFadden, a Houston-based art critic, cultural writer, and arts administrator, is Communications and Marketing Manager at Project Row Houses. His writings have been published in *Arts+Culture Texas, The Brooklyn Rail, Free Press Houston, Glasstire,* and *Houstonia,* as well as in exhibition catalogues. McFadden is a former member of the Houston- and Chicago-based curatorial collaborative Suplex.

Assata-Nicole Richards, PhD, is the Founding Director of the Sankofa Research Institute (SRI), a nonprofit with a mission to "create knowledge to build community." SRI, employing community-based participatory research, works collaboratively with academic researchers, community organizations, and funders to generate empirical evidence to inform social change. Richards is an adjunct professor at the University of Houston, teaching courses in the sociology department and the arts leadership program. In 2016, Houston mayor Sylvester Turner appointed Richards to chair the Housing Transition Committee. She is chair of the board of directors of the Emancipation Economic Development Council, a community-led effort to inspire hope and contribute to the revitalization and preservation of the Third Ward.

Photo Credits